ESTHER BUBLEY

Esther Bubley by Grace Rothstein, ca. 1959

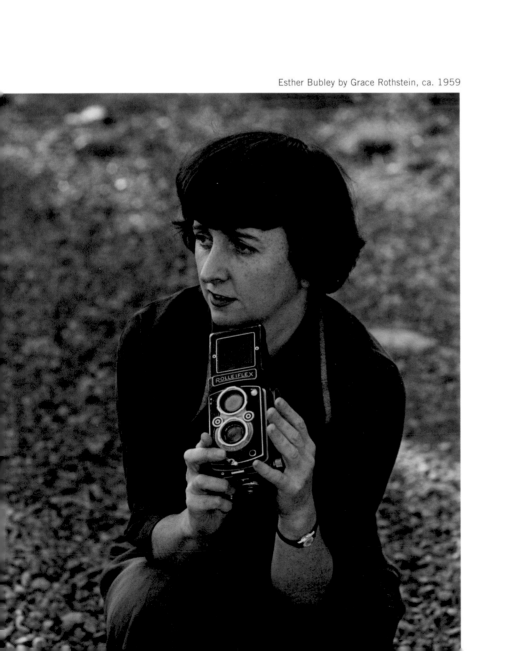

ESTHER BUBLEY
On Assignment

By Bonnie Yochelson
with Tracy A. Schmid

aperture

*For more than fifty years I have been a photographer working in varied fields —
Photo Journalism, Industry, Advertising, and on my own projects. As a documen-
tary and "straight" photographer, I feel that accurate depictions of life can be
educational, instructive and also provide aesthetic pleasure. As to subject, people
in all their aspects and relationships are of major interest to me, but I enjoy
taking pictures of almost everything.*[1]

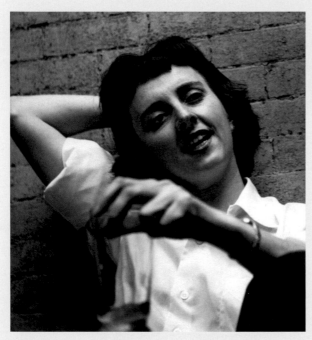

Esther Bubley (photographer and date unknown)

With characteristic directness and modesty, Esther Bubley wrote these
words in the 1990s, when American photography was becoming
increasingly foreign to her. She was surprised by the steep prices that
prints were commanding and mystified by the manipulated and ironic
images of photographers like Cindy Sherman and Sherrie Levine.
Inspired by *Life* magazine and the images of the Depression-era Farm
Security Administration (FSA), Bubley was drawn to photographs that
revealed the world of ordinary people. She expected her photographs to
be seen by millions on the printed page, not by a few on a gallery wall,
and she strove to tell human stories in a series of captioned images, not
to show isolated works. To understand Bubley's achievement is to
understand her era — the golden age of American picture magazines.

Esther Fern Bubley was born in Phillips, Wisconsin, on February
16, 1921, the fourth of five children of Russian Jewish immigrants
Louis and Ida Bubley. In search of work, the couple moved from
Minnesota (where their first three children, Enid, Anita, and Claire
were born) to Wisconsin (where Esther and Stanley were born) to
upstate New York and finally to Superior, Wisconsin, in 1931. The
family achieved a measure of stability in Superior, where Ida operated
a general store and Louis established an auto parts business.

In high school, Esther became interested in photography when, as
yearbook editor, she replaced conventionally posed photographs with
more candid images like those she had seen in *Life*. In 1936, working
with a cheap 35-millimeter camera, she won first prize in a yearly
photography contest conducted by the *Superior Evening Telegram*.
After graduation, she followed her sisters Claire and Anita to Superior
State Teachers College. She then found a job in a Duluth, Minnesota
photo-finishing lab, saved her money, and enrolled for a year in the
Minneapolis School of Art. There she learned studio technique, using
a view camera on a tripod with carefully controlled lighting.

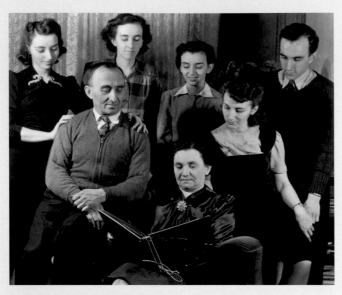

Bubley Family, Superior, Wisconsin, 1940
Standing: Claire, Esther, Anita, Stanley; seated: Louis, Ida, Enid

In 1940, Bubley was a nineteen-year-old Midwestern art student; two years later, she was working for the renowned Roy Stryker, whose FSA photographers had inspired her in high school. Bubley's path to the center of American documentary photography was short but circuitous. Unable to find a job in Minneapolis, she traveled to Washington, D.C., where Enid was working as a nurse and Claire as a court reporter, but where she was unable to find work as a photographer. She then tried New York, where her student portfolio elicited praise from distinguished photographers — Edward Steichen, Nicholas Muray, Anton Bruehl and Toni Frissell — but earned her no job offers. A job taking snapshots of customers in a Brooklyn night club ended when she learned that her duties included "being the boss' girlfriend."[2] *Vogue* hired her to photograph gifts for its 1941 Christmas issue, but she shattered an expensive glass vase by placing floodlights too close to it and was not rehired. Unemployed, she took courses at the School of Modern Photography, a trade school that offered her a scholarship.

Bubley's New York misadventures ended in the spring of 1942, when she returned to Washington to microfilm documents for the National Archives. The job was boring and also frustrating because the other technicians were so poorly trained. Recognizing her distress, Bubley's supervisor, Vernon Tate, introduced her to his friend Roy Stryker, whose Historical Section had recently been transferred from the FSA to the Office of War Information (OWI). Stryker assigned Bubley to the OWI darkroom, where she studied the photographs she processed as they came in from the field. He also ensured that she met the OWI photographers and encouraged her to photograph in her spare time. As Bubley later wrote, "Dorothea Lange, Russell Lee, Jack Delano, Ed and Louise Rosskam and others became not just names, but friends and in a sense, teachers."[3]

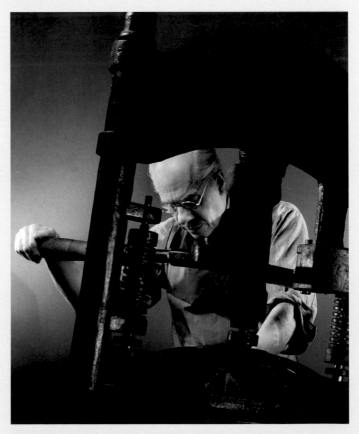

Genre study for Minneapolis School of Art photography class, 1940

In January 1943, Bubley photographed Dissin's boarding house, a once-elegant Massachusetts Avenue residence that had recently been divided into twenty-one apartments. It was a natural subject for her, since her sister Enid, who appears in several of the photographs, lived there. It was also a perfect subject for the OWI file as it documented a common response to Washington's wartime housing shortage. Bubley's file essay was factual and colorful:

> Rents range from $42.00 to $47.50 per month for room and board (two meals a day). The guests are government clerks whose average salary is $1,620 per year, and they come from all parts of the country – California to New York. There are a few young men living in the house, and romance flourishes.[4]

Stryker was sufficiently impressed with the project to promote Bubley to field photographer, and in the course of the next year, she contributed more than 2,000 images to the OWI file. Because she could not drive a car, Bubley stayed close to home, photographing topics of her choice: woman streetcar operators, a wartime innovation; the Western Union office, from which telegrams were sent overseas; jitterbuggers at the Elk's Club ("the cleanest dance in town"); patrons of the Sea Grill bar; African-American slums within blocks of the Capitol; and visitors to a suburban amusement park. Further exploring Washington's housing shortage, she documented Arlington Farms, a suburban residence for women with government jobs, and the United Nations Service Center, a serviceman's hotel.

In these early photographs, Bubley began to create extended narratives by gaining the cooperation of her subjects. At the Service Center's day care nursery, for example, she met second-class Petty Officer Hugh Massman, who invited her into his home to photograph his wife and their eight-week old son.

The photographs also reveal Bubley's interest in spectators. Photographing patriotic celebrations, she focused more on the crowds than the speakers or marchers. In 1943, Bubley began to gain public recognition: one of her photo-

graphs was reproduced in *U.S. Camera Annual*, American photography's most prestigious publication, and another received an Art Directors Club award.

Just as Bubley was getting started as a government photographer, Stryker was preparing to leave Washington. Since 1935, he had fought to protect the mission of the FSA file, whose 77,000 photographs served the publicity needs of its agency and documented the Depression. With his 1943 transfer to the Office of War Information, Stryker realized that his ambitious project was in jeopardy. That fall, he moved to New York to establish another photographic file, this time for a private company, the Standard Oil Company (New Jersey).

Before leaving government, Stryker gave Bubley a promising out-of-town assignment. Mindful of her inability to drive, he asked her to document American bus travel, which had dramatically increased with the rationing of gasoline and tires. Bubley lived on buses for four weeks, traveling to Pittsburgh, Indianapolis, Chicago, Columbus, Cincinnati, Louisville, Memphis, Nashville, Chattanooga, and back to Washington.

She photographed passengers and employees, a Pittsburgh garage, and the home of Cincinnati bus driver "Red" Cochran. And she contributed a lively twenty-page essay to the file, which reveals her easy rapport with her subjects. One bus driver, for example, confided: "They might tell you … that [bus drivers] go in for athletic sports … but don't believe it. Wolfing around, that's what they do — chase women. They shoot craps, but the company doesn't permit it, so don't mention it."[5] Her commentary, like her photographs, often captured off-beat moments:

> A soldier near the back of the bus suddenly and loudly announced to the world in general that he was going to Memphis. "Memphis is God's country," he shouted, then started singing, "Oh there's no place like Memphis." As unexpectedly as he had started, he quieted down.[6]

DISSIN'S BOARDING HOUSE, WASHINGTON, D.C., 1943
Office of War Information

Bubley's sisters Enid and Claire appear in many of the thirty-seven photographs of Dissin's boarding house. Enid lived at Dissin's and met her husband there. Some historians have discerned a subversive message in the images of single men and women rooming together in a wartime boarding house. Bubley offered a simpler interpretation of this self-assigned project: "I did the boarding house pictures because one of my sisters lived there, and it was easy to do."

Bubley wrote engaging captions for the photographs; with later assignments, she was generally too rushed to do more than provide identification.

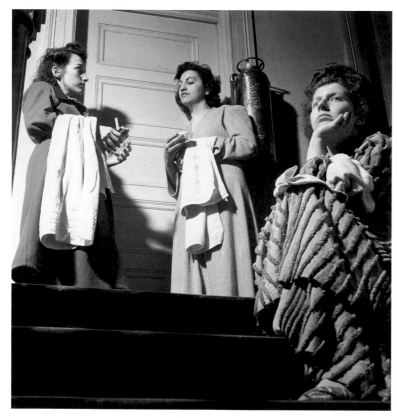

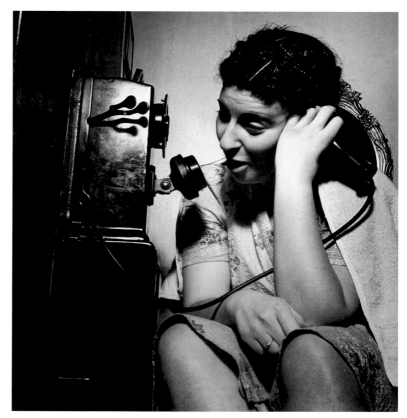

"The schedule for use of the boarding house bathroom is worked out so that each person has eight minutes in the morning. It is social suicide to ignore the schedule and cause a tie-up like this." The woman at the left is Bubley's sister Enid.

"The telephone in a boarding house is always busy."

OPPOSITE PAGE: "A bridge game does not disturb the sleeper."

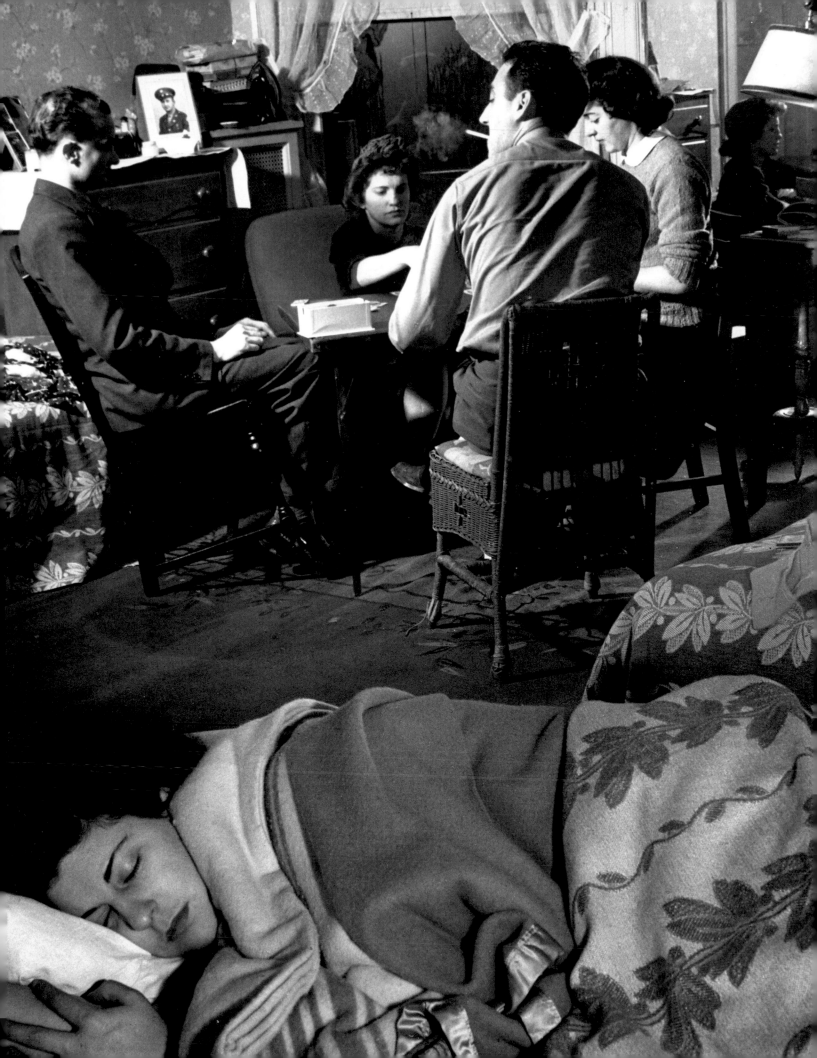

BUS STORY, 1943
Office of War Information

Despite slow film and cumbersome equipment, Bubley produced an intimate, varied portrait of wartime bus travelers. Her depictions of bored, uncomfortable, and sleeping travelers inspired one critic to characterize her subjects as a "nation of zombies," a description that overlooks the many images of companionship, whimsy, and family closeness.

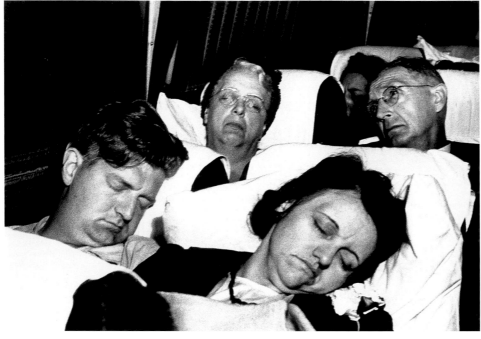

A Greyhound bus bound for Chicago from Cincinnati at two A.M.

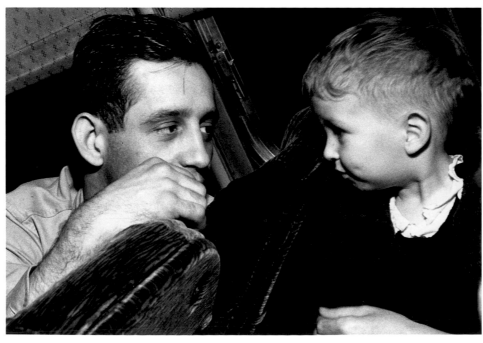

Bus passengers getting acquainted on a Greyhound bus trip from Louisville to Memphis

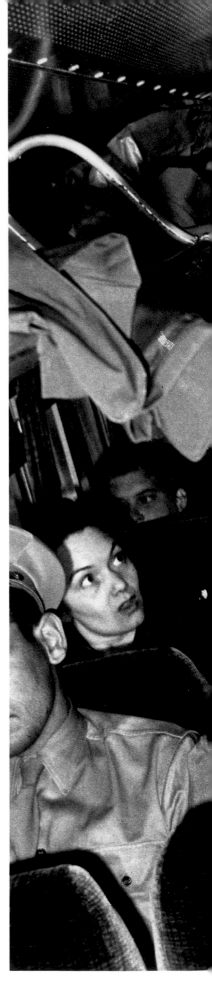

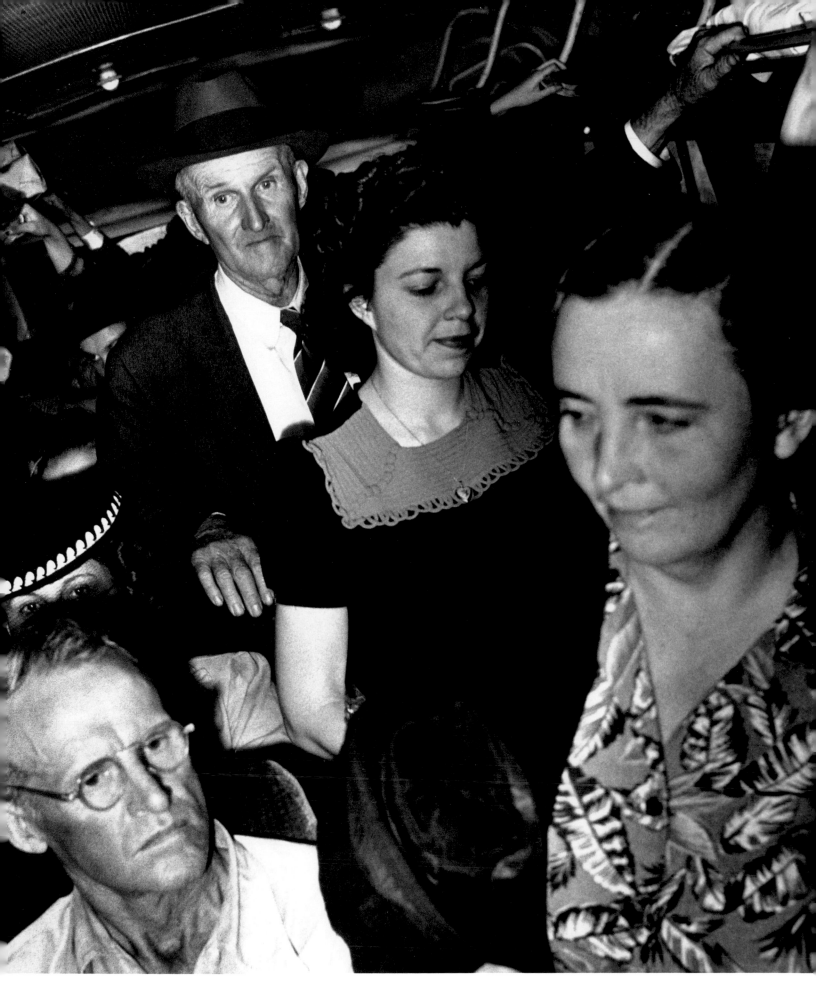

A crowded bus en route from Knoxville to Bristol, Tennessee

Because Bubley joined Stryker's unit near its closing, little of her Office of War Information work was published. Stryker, however, brought "Bus Story" to the attention of photography magazines. In May 1944, *U.S. Camera* placed one of Bubley's photographs on its cover, and the following month it published "Children by Bubley," featuring "Bus Story" images and naming her "one of today's outstanding young photographers."

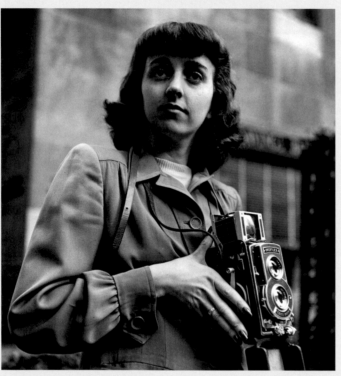

Esther Bubley by John Vachon, 1944

In May, *Minicam* gave a full page to a "Bus Story" photograph and in June, it published a four-page spread, "Take a Bus … Photographs by Esther Bubley." The magazine advised its readers to follow Bubley's example and "make something out of what first appears to be nothing," thus defining her special talent.

In January 1944, Bubley accepted Stryker's invitation to work for Standard Oil and moved to New York, leaving her sisters behind. John Vachon, Gordon Parks, and Edwin and Louise Rosskam also left OWI for Standard Oil, where they were joined by New York-based photographers Sol Libsohn, Arnold Eagle, Harold Corsini, and Todd Webb. After the war, Russell Lee joined the group. The photographers worked freelance for what was then the extravagant sum of $150 per week plus expenses. Although they went on assignment alone, Stryker's offices at 30 Rockefeller Plaza became their meeting place where close friendships were formed. Finding an inexpensive apartment on the Lower East Side, Bubley, at age twenty-three, became a sophisticated New Yorker who wore tailored suits and kept a fresh manicure.

The unlikely relationship between Stryker, a New Dealer, and the Rockefellers' oil company was brokered by Edward Stanley, who had left OWI to work for a New York public relations firm. Standard Oil, the firm's biggest client, was weathering a press disaster, following disclosure of its pre-war dealings with a German petrochemical company. It was Stanley's idea that a photographic file which documented the accomplishments of the oil industry might improve the company's image. The file would be used for the company's publications — especially its magazine the *Lamp* — but would also be available to the public in return for only a published credit line. Critical to its success was the file's intended size and breadth: it would contain at least 25,000 images —

photographs of medical centers and playgrounds as well as oil rigs and filling stations. To justify the broad scope of the project, Stryker coined the motto "a drop of oil in everything."

For four years, Stryker was given a free hand, and the Standard Oil Photographic Library became a regular destination for picture researchers. Among those who signed the 1946 guest book were representatives of magazines (*Life*, *Mademoiselle*, *Saturday Evening Post*, *Holiday*, and *Popular Science*), advertising agencies (Young & Rubicam and J. Walter Thompson), educational publishers (Scholastic and Groliers), corporations (Coca-Cola and General Electric), and news agencies (Reuters and UPI). Academics and a few photographers, most notably Edward Steichen, also visited, and the photographic library became the subject of stories in *Fortune* (September 1948) and *U.S. Camera* (December 1948).[7]

Although most Standard Oil photographers held liberal political views and had reservations about serving corporate interests, they were grateful to be employed. Stryker was a forceful but nurturing leader who, according to Bubley, "had an uncanny ability to stimulate ideas in photographers."[8] In his tongue-in-cheek poem, "The Children of Esso," John Vachon captured the group's spirit:

In the beginning, there was Oil,
 and the Oil was Standard (N.J.)
And behold, there was sent a man,
 and his name was Stryker.
And he gathered about him many
 who were makers of images
And these he called photographers.
Yea, even Corsini, the Far Wanderer; and Todd the Terrible;
 and Vachon the Pure of Heart; and Sol of the Burning
 Bush, and the High Priestess Esther; Glittering Gordon,
 dark of skin; and Arnold of the Honeyed Tongue.
And these were called the Children of Esso.
And Roy Stryker blessed them, saying,
 "Be fruitful and multiply."[9]

In the spring of 1945, Stryker sent Bubley to Texas with only the most general instructions. Having finally learned to drive, she discovered Tomball, a town thirty miles outside of Houston, which was dominated by the Humble Oil Company, a Standard Oil subsidiary. In six weeks, she produced 600 photographs of the town, images that became a highlight of the library. The series surveys the town's commerce, industry, schools, churches, and recreation and conforms closely to a six-page "outline for photo-documentation of a small town" that Bubley had written at OWI. Bubley operated within Stryker's guidelines but was artistically unconstrained: "Before starting an assignment, [we discussed] with him its ramifications. Socially, geographically, economically — every way but photographically."[10]

Using a Rolleiflex camera, which was hand-held but too large to go unnoticed, Bubley achieved a new measure of naturalness in Tomball:

In doing street scenes and various shots of that type, I found the best procedure was to take a few pictures, then answer the questions of the curious as to what I was doing and why. Then to stand around and wait until my subjects got thoroughly bored with me and went back to their own conversations or interests.[11]

For indoor scenes, she discarded the floodlights she had used in Washington, which had created a stage-like effect, and used flashbulbs, which allowed for greater spontaneity. Stryker recalled the excitement of the town when they saw Bubley's contact sheets: "They didn't realize she was there, she wasn't invading them, she was sort of floating around. And all of a sudden they saw themselves, not unpleasantly, yet with her discernment … and they said, 'My God, it's interesting.' "[12]

The local response to Bubley's photographs was so enthusiastic that Standard Oil produced an exhibition of mounted enlargements that was shown at Humble's Tomball headquarters, the town bank, and the Harris County Fair. In December 1945, *Minicam* published a feature article, "Town Portrait," and in April 1946, *Coronet*, a small-format general interest magazine, published a twenty-page photo-essay entitled "Oil Town, U.S.A." Russell Lee later noted that the Tomball story "could be a small book."[13]

While Stryker's office promoted the Tomball story, Bubley remained in the Southwest for six more months, traveling to remote areas in west Texas and New Mexico and contributing 400 more photographs to the file. Moving from one industrial site to the next, she sought out human stories, befriending a desert pipeline rider in Bandera County, a field nurse in Andrews County, and a family of sheep ranchers in Terrell

County. Driving along endless highways, she stopped to photograph road signs that captured Texas culture: "Quit growling, we have to use this road every day," and "Howdy stranger, come in, we ain't mad at nobody." She also photographed signs announcing peculiar sounding Texas towns, from the prosaic Sand, Hewt, and Cistern, to the bombastic Splendora, Eden, and Sublime.

After nine months in the field, Bubley drove to Mexico for a well earned two-month vacation. In her journal, she wrote: "I dunno. By the time I get back I shall have achieved a fascinating state of mental blankness. I will be ready to do something. What? That's what bothers me ... I have this strange feeling of being finished with one era, ready for another. Time will tell."[14]

Indeed, the Texas trip marked the end of Bubley's apprenticeship and earned her the respect of her Standard Oil colleagues. In the next few years, she traveled the country documenting subjects as diverse as logging in North Carolina; iron ore mining in Hobbs, New Mexico; grain elevators in Duluth, Minnesota; and cabbage farming in Springfield, Massachusetts. Between assignments, she, like the other "Children of Esso," drew a paycheck by contributing to a project on the New York harbor.

At Stryker's suggestion, Bubley also revisited "Bus Story," which easily illustrated the theme of "a drop of oil in everything." In her search for more natural effects, she turned to a 35-millimeter camera, which attracted less attention than the larger Rolleiflex and required less light. Her defiance of Stryker's ban on the 35-millimeter camera and his enthusiastic acceptance of her practice became legendary among the Standard Oil ranks. Her second version of "Bus Story," this time entitled "America on Wheels," was published in the April 1948 issue of *Pageant*, a small-format magazine similar to *Coronet*, as a nine-page photo-essay with fifteen images. In 1948, the Standard Oil board of directors decided to cut the library's budget almost in half. The library was highly respected, and other corporations imitated it, but its effect on Standard Oil's public image was unclear. Moreover, the file

already well exceeded its intended size: the company had spent almost a million dollars, and the library contained almost 70,000 images. With his project in jeopardy, Stryker sought a new sponsor and left Standard Oil in 1950.

Stryker's new patron was the Allegheny Conference on Community Development, which sought to develop a Pittsburgh Photographic Library (PPL) to draw attention to Pittsburgh's post-war revitalization, and the University of Pittsburgh, where the library was to be located. Stryker's inaugural effort was a large exhibition for the Carnegie Museum entitled "People in Pictures," which documented the philanthropic activities of the city's Community Chest.

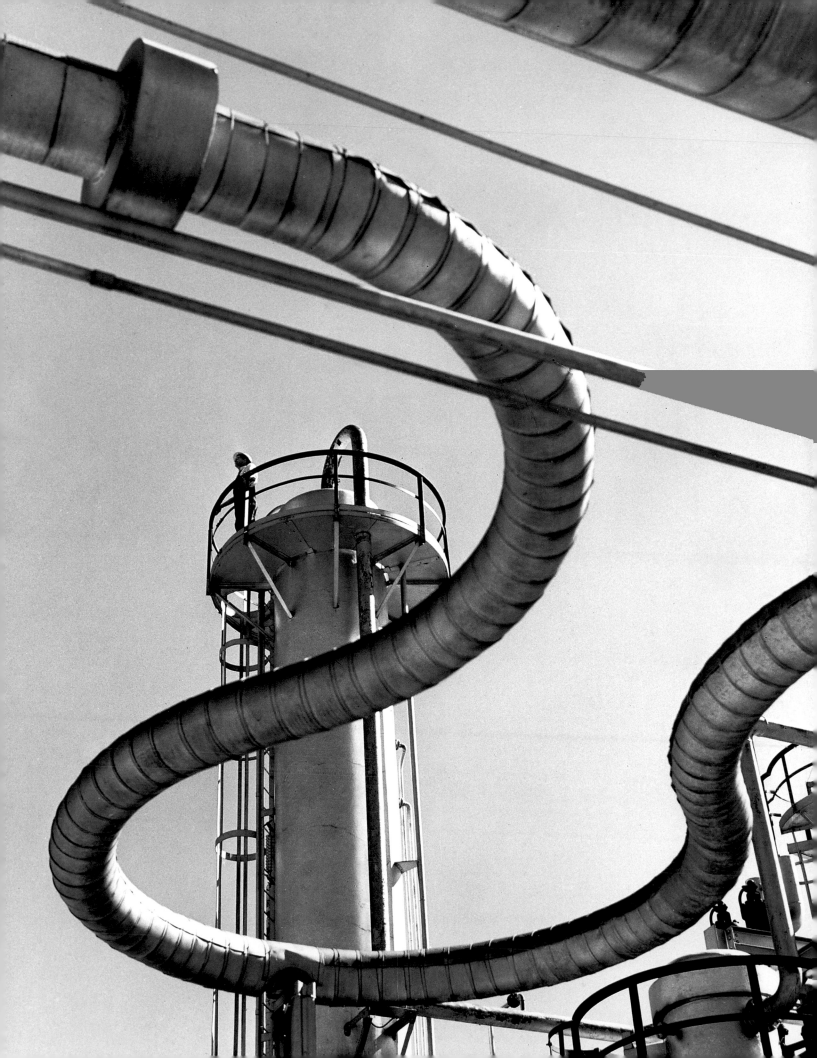

TOMBALL, TEXAS, 1945
Standard Oil Company (New Jersey)

The town of Tomball was founded in 1906, when the railroad came through southeast Texas. In 1933, the Humble Oil Company bought the town's mineral rights in exchange for free gas for its residents. Everyone in Tomball, including the mayor, worked for the company, and most people lived in company camps — one for supervisors and another for blue-collar employees. Bubley's photographs depict a close-knit, contented community. As she explained, "Everybody says to me, 'Oh they look so happy.' And I say, 'They look so happy because they had jobs,' and they really were very good jobs."

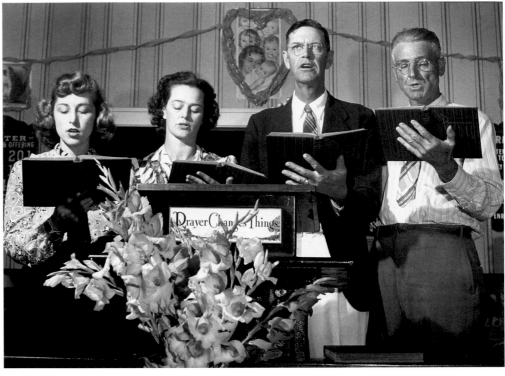

Tomball Baptist Church Quartet

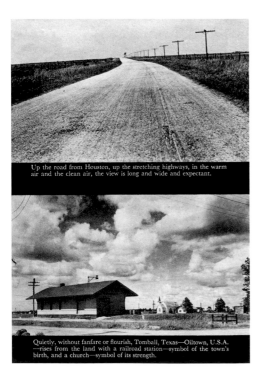

Up the road from Houston, up the stretching highways, in the warm air and the clean air, the view is long and wide and expectant.

Quietly, without fanfare or flourish, Tomball, Texas—Oiltown, U.S.A. —rises from the land with a railroad station—symbol of the town's birth, and a church—symbol of its strength.

From *Coronet*'s photo-essay "Oil Town, U.S.A."

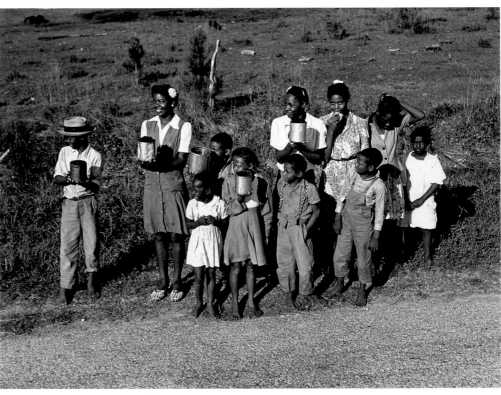

Berry pickers selling their wares

16

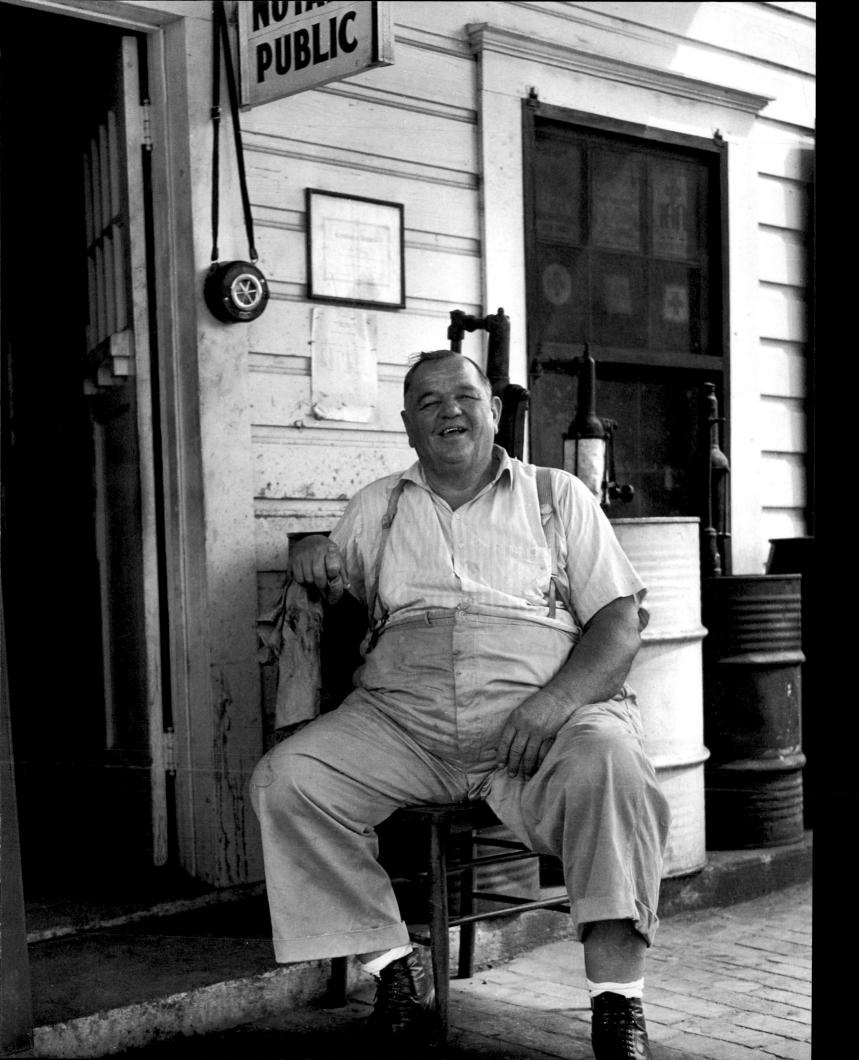

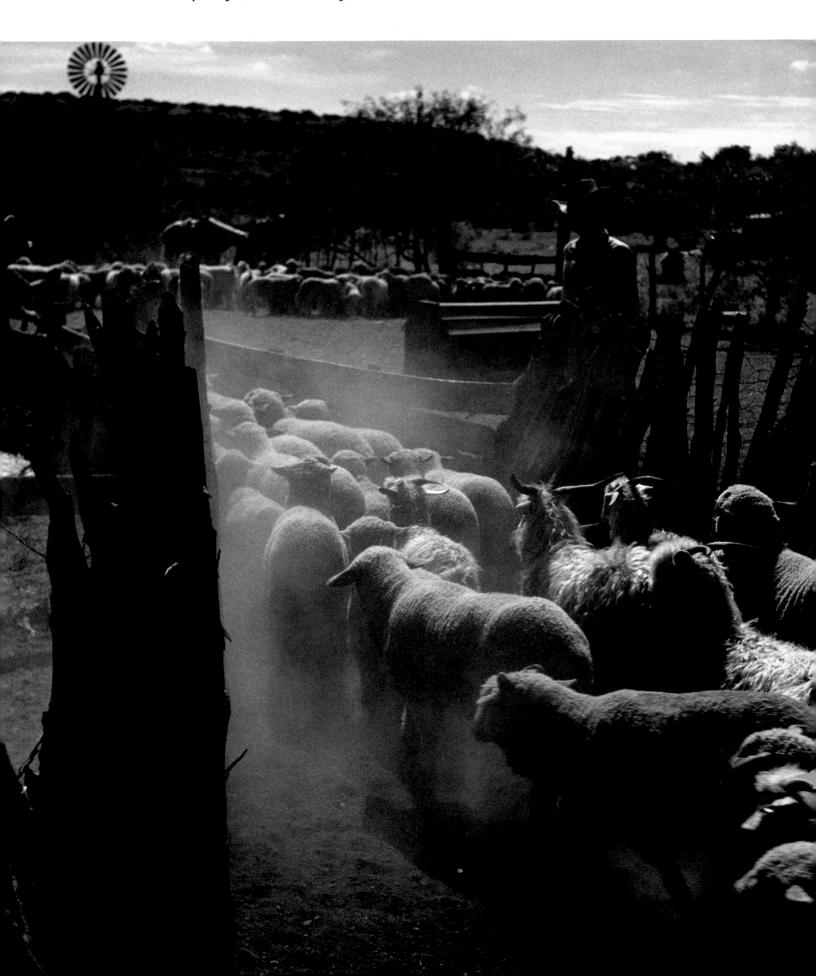

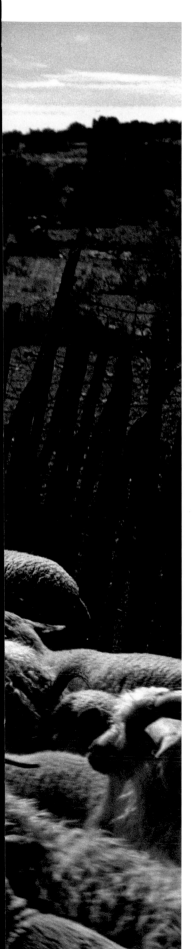

LEFT: Sheep driven into pens

After leaving Tomball in June 1945, Bubley traveled west across Texas for six months. She spent the most time in Andrews, another Humble Oil town near the New Mexico border, but also documented areas with no direct link to the oil industry, including the Noble Holt Ranch.

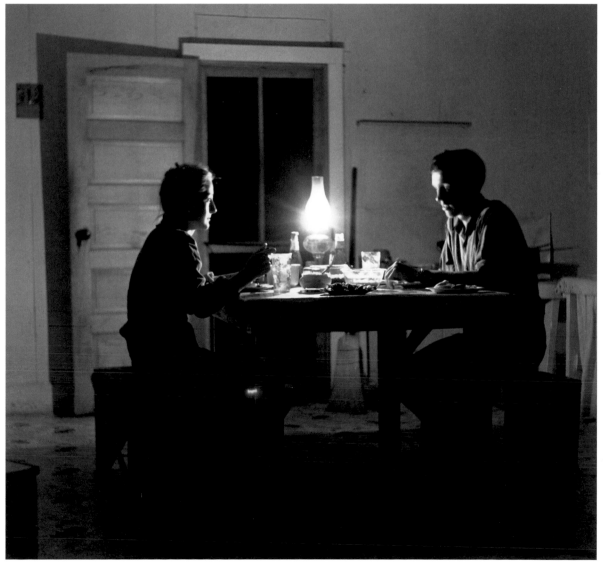

Willie and Gene Bishop, newlywed farmhands, having dinner

BUS STORY, 1947
Standard Oil Company (New Jersey)

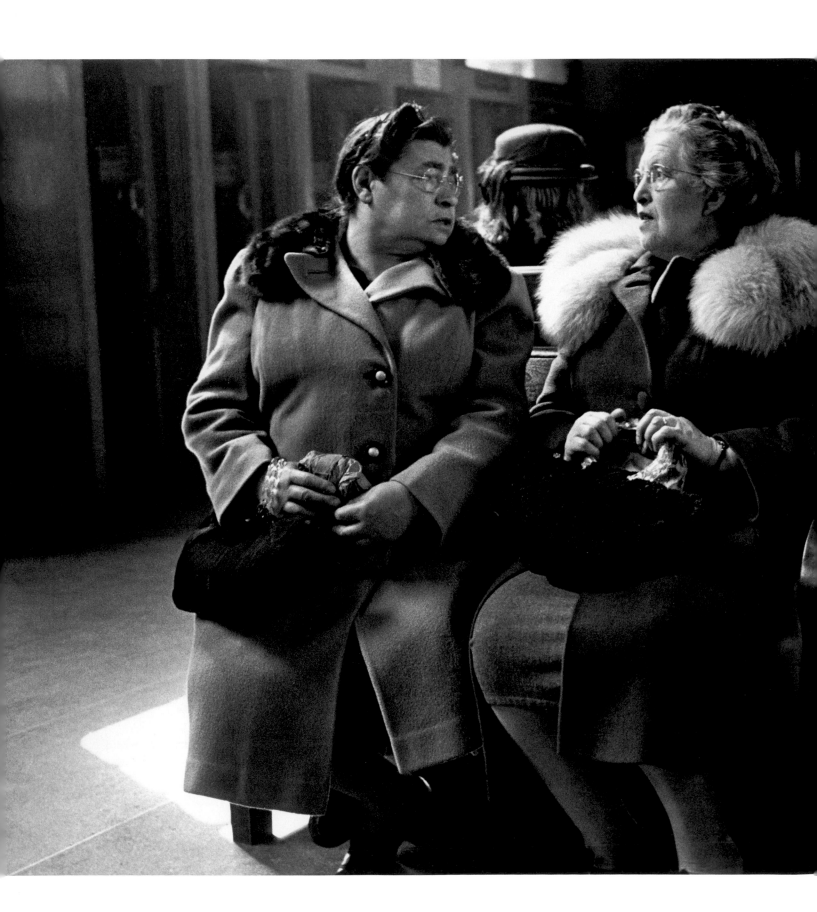

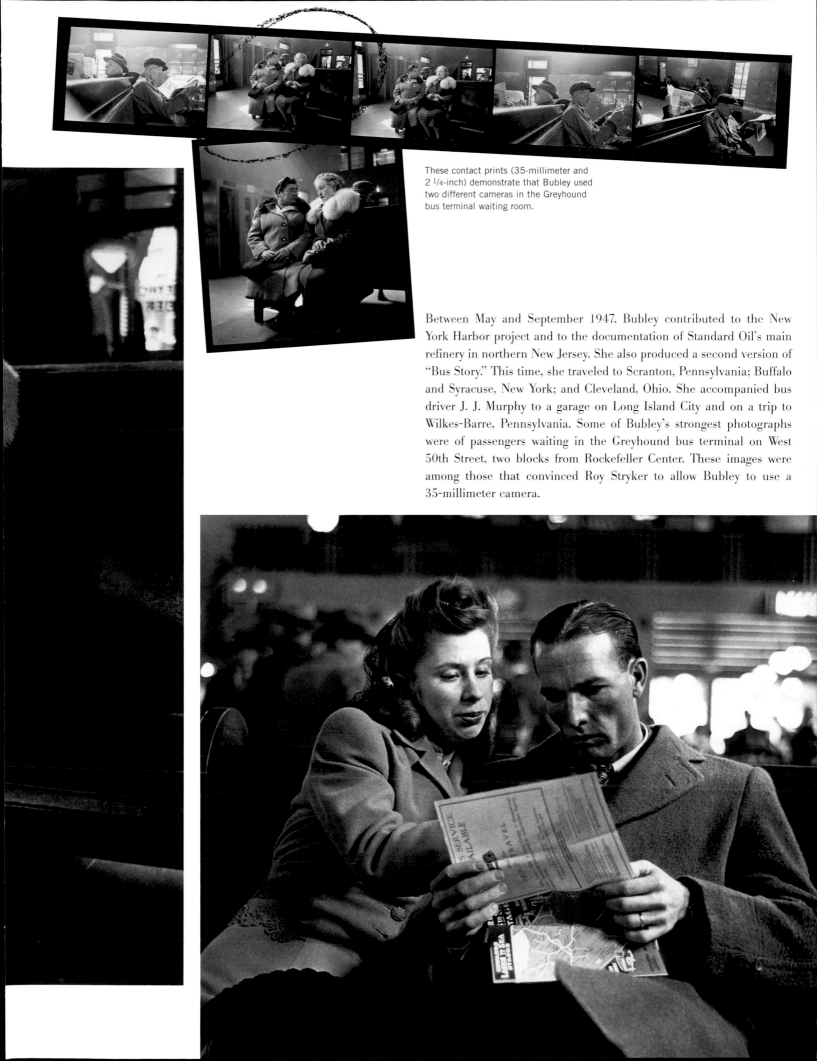

These contact prints (35-millimeter and 2 1/4-inch) demonstrate that Bubley used two different cameras in the Greyhound bus terminal waiting room.

Between May and September 1947, Bubley contributed to the New York Harbor project and to the documentation of Standard Oil's main refinery in northern New Jersey. She also produced a second version of "Bus Story." This time, she traveled to Scranton, Pennsylvania; Buffalo and Syracuse, New York; and Cleveland, Ohio. She accompanied bus driver J. J. Murphy to a garage on Long Island City and on a trip to Wilkes-Barre, Pennsylvania. Some of Bubley's strongest photographs were of passengers waiting in the Greyhound bus terminal on West 50th Street, two blocks from Rockefeller Center. These images were among those that convinced Roy Stryker to allow Bubley to use a 35-millimeter camera.

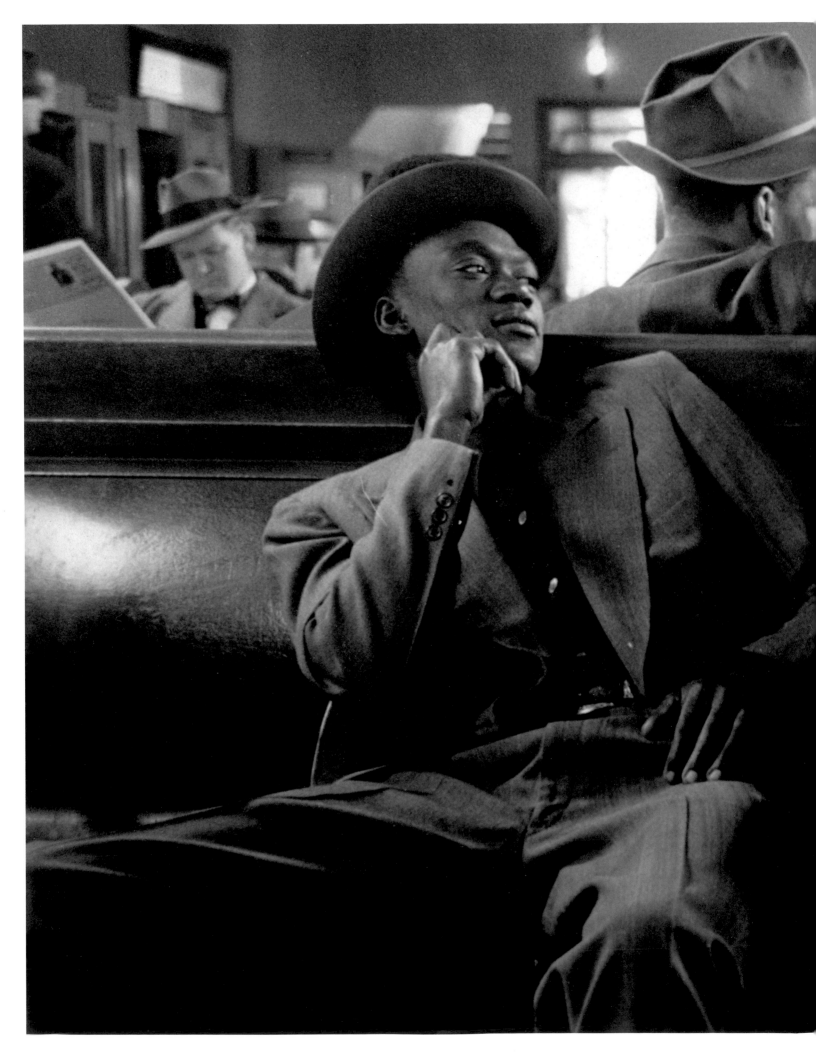

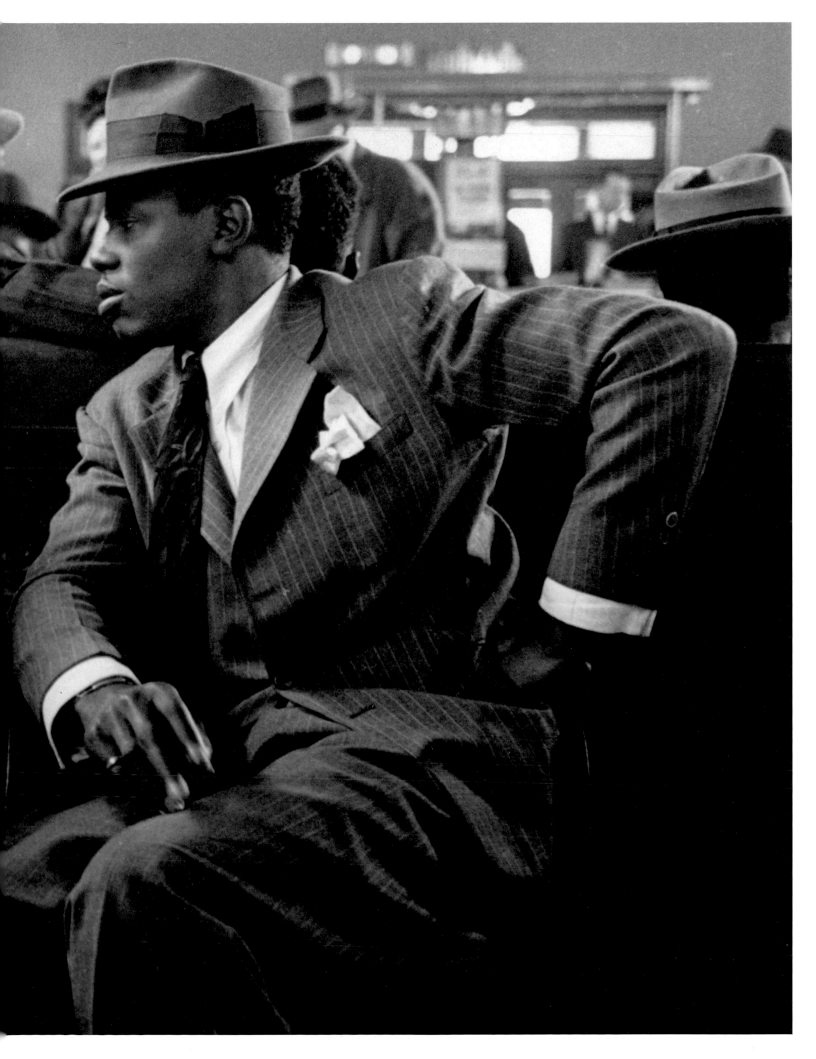

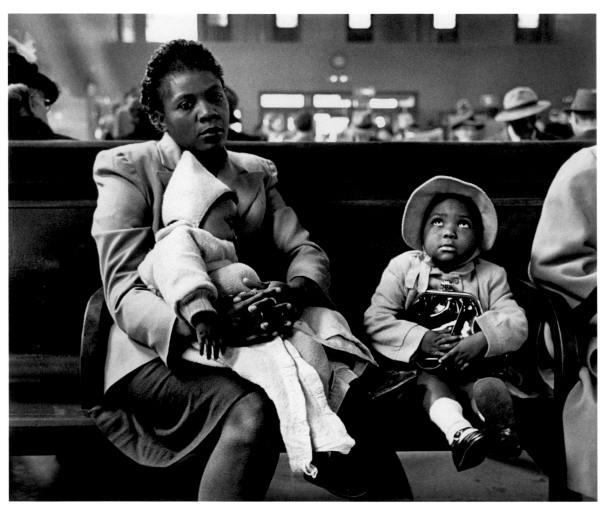

From "Esther Bubley: Realism," by Morton Seif, *Photo Arts*, May 1951

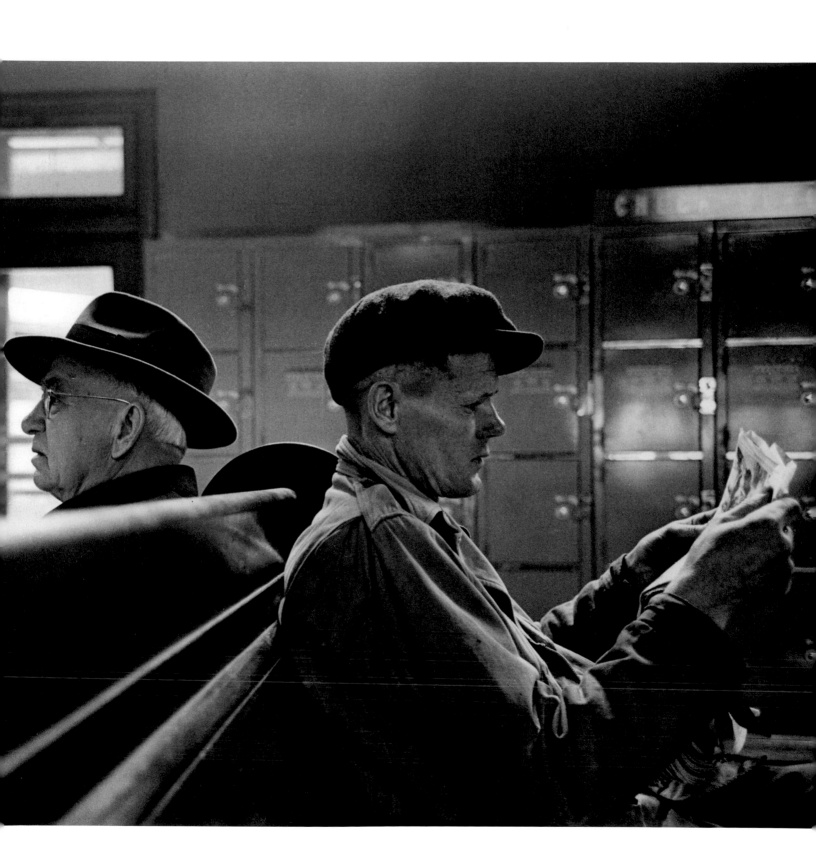

Bubley spent the summer of 1950 in Pittsburgh, and a highlight of the local Community Chest exhibition, *People in Pictures*, was her portrait of Jackie Solomon, an eight-year-old boy in treatment at the Child Guidance Clinic. Bubley spent a week in Jackie's home (four people in four very small rooms) and accompanied the family to the clinic and to an amusement park, an outing recommended by Jackie's therapist.

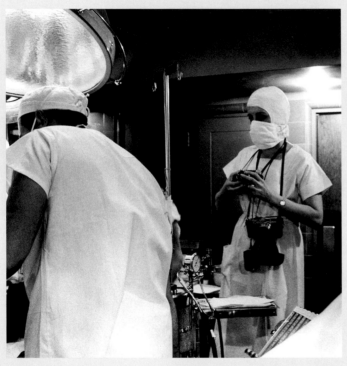

Bubley at work during one of the several surgeries that she photographed (photographer and date unknown)

In December 1951, *Pageant* published "A Matter of Love," a fourteen-page photo essay on Jackie's therapy. Now in his sixties, Jack Solomon remembers his summer at the clinic as the turning point in his life and Bubley "like a member of the family." "I look at the pictures, and I don't remember her being there, he recalls. But when she left, my sister and I, we complained bitterly…. She didn't treat us as special, but she treated us like we meant something to her."[15]

As she continued working for Standard Oil (the library remained in operation through the 1950s) and for Stryker in Pittsburgh, Bubley developed a thriving freelance practice outside of Stryker's orbit. In 1947, she began what was to be a longstanding relationship with the Children's Bureau, a federal child welfare agency. Bubley was hired to document the agency's programs, including a Cerebral Palsy Pre-School Center and a Lower West Side Dental Clinic, and contributed several thousand photographs to the Children's Bureau's files. Her photographs illustrated articles in the Bureau's monthly journal, *The Child*, and appeared on more than thirty covers. The June 1949 issue, for example, featured her photograph of Gordon Parks's nine-year-old daughter Toni. In 1952, the Bureau mounted an exhibition of Bubley's photographs in its Washington office, advising her that "it builds our own morale to be identified with your work."[16]

One of Bubley's most productive professional relationships was with John G. Morris, picture editor of the *Ladies' Home Journal* from 1946 to 1953. The *Journal*, whose motto was "never underestimate the power of a woman," was the nation's leading women's magazine and featured a section called "How America Lives" about families from different regions and income groups. Having honed his skills at *Life*, Morris turned "How America Lives" into a photographer's showcase. He paid lavishly — $1,500 plus expenses per story — and urged photographers to take their time and stay with a family for

several weeks if needed. "Choosing a photographer for 'HAL' was like awarding a monthly Pulitzer Prize," Morris noted.[17]

On Stryker's recommendation, Morris hired Bubley in 1948 to photograph the Rood family, who owned a farm in Wahoo, Nebraska. Uncertain if a Standard Oil photographer could fulfill the narrative demands of a photo-essay, Morris accompanied Bubley to Wahoo to get her started. He quickly learned how well prepared she was for the assignment and how well it suited her talents. "Bubley had the ability to make people forget she was even around; her pictures achieved incredible intimacy," Morris later recalled.[18] The August issue of the *Journal* included nineteen photographs of the Rood family. Bubley subsequently photographed eight "HAL" families; seven "Profiles of Youth," featuring teenagers; and three "How Young America Lives," which focused on newlyweds. Bubley loved these stories, remarking that they were easier than Standard Oil assignments, because she did not have to write her own captions.[19]

Another of Bubley's magazine clients was *Our World*, "a picture magazine for the Negro family," which was modeled on *Life* and was published from 1946 to 1955. Among the photographers represented in the first issues were Gordon Parks, Arnold Eagle, and Bubley. In 1946, Bubley produced stories on Howard University School of Medicine in Washington, D.C., the meat-packing industry in Chicago, and African-American life in New Orleans. Her most probing article for *Our World* was "Hope for Sick Minds," a report on conditions in mental hospitals, for which she traveled to Georgia, Maryland, and South Carolina. Most likely *Our World* offered Bubley the assignment after seeing her 1949 *Ladies' Home Journal* series on mental health.

When Bubley first met Ray Mackland, *Life's* assignment editor from 1946 to 1961, he was hesitant to hire her, concluding that because of her shyness, she did not have a "*Life* personality." Mackland was eventually proved wrong. A photo from her first *Life* assignment, a feature story about a "cherub choir" of young children, was chosen for the magazine's 1951 Easter issue cover. No other assignments followed, however, and to show her worth, Bubley entered *Life's* "Young Photographers Contest" that fall. Aimed at professional photographers and offering $15,000 in prizes, the prestigious contest, which coincided with the magazine's twenty-fifth anniversary, attracted

1,730 entrants. Among its seven judges were Stryker; Steichen; and Edward Thompson, *Life's* managing editor and Mackland's boss. Bubley's picture story won the $1,000 third prize; it was called "The People Who Go to Hospitals" and consisted of seventeen photographs of waiting rooms in out-patient clinics of New York's St. Luke's Hospital. One of the judges remarked, "The story of a hospital has never before been done with such warmth of understanding."[20]

After the contest, Bubley became a regular contributor to *Life*, earning the trust of its staff, who allowed her to depart from their scripts, and developing a productive relationship with its picture editor Peggy Sargent. *Life's* corporate culture was competitive, with department heads routinely commissioning more stories than could be published and vying for space in the magazine. Bubley was especially proud of her success rate; almost all of her assignments resulted in published stories, forty in all.

In addition to generating *Life* assignments, Bubley's success in the "Young Photographers Contest" inspired Stryker to bring her back to Pittsburgh to photograph Children's Hospital for the Pittsburgh Photographic Library.

In November 1951, Bubley spent several weeks living at the hospital, documenting its activities around the clock. She submitted 832 contact prints, 350 enlargements, and a memo to the file, in which she edited the photographs into story sequences:

> I have separated the full story on Children's Hospital into fifteen major divisions. These are arranged in a sequence that I hope tells the complete story of the hospital. Each one is also a story by itself. The major divisions are subdivided and, again, almost each subdivision can be used as a story sequence by itself. The individual pictures are arranged in sequence within the divisions.[21]

Her most memorable Pittsburgh story occurred by chance. On a Sunday afternoon, a frantic mother brought her three-and-a-half-year-old foster daughter to the hospital gasping for breath. While the child was still in the hospital's vestibule, the staff performed an emergency tracheotomy to save her life. As the doctors responded to the emergency, so did Bubley, capturing the crisis from the initial chaos to its happy ending. Bubley developed a specialty in hospital stories, particularly about surgery, which combined intimacy with life-and-death drama.

CHILD GUIDANCE CLINIC, 1950
Pittsburgh Photographic Library

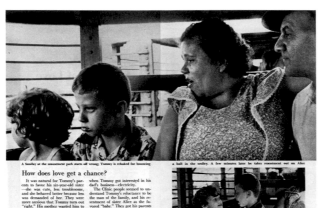

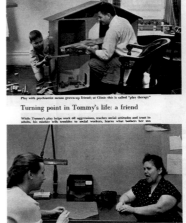

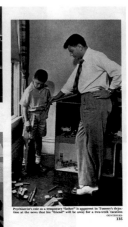

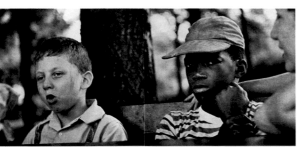

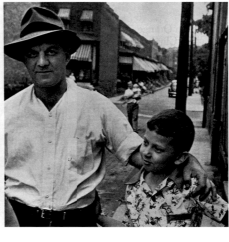

From "A Matter of Love,"
Pageant, December 1951

Bubley's photographs of a patient at the Pittsburgh Child Guidance Clinic were featured in the *Pageant* magazine photo-essay, "A Matter of Love." The twenty-two images, bold subheadings, and minimal text tell a complex story efficiently: Jackie Solomon, called "Tommy" in the story, fights with his sister, rebels against his parents, has trouble making friends, and finds support at the Pittsburgh Child Guidance Clinic. In the end, "Tommy is surprised ... that grown-ups can be fairly reasonable people, if you handle them right. He doesn't need a substitute father anymore."

OPPOSITE PAGE: Jackie Solomon in play therapy

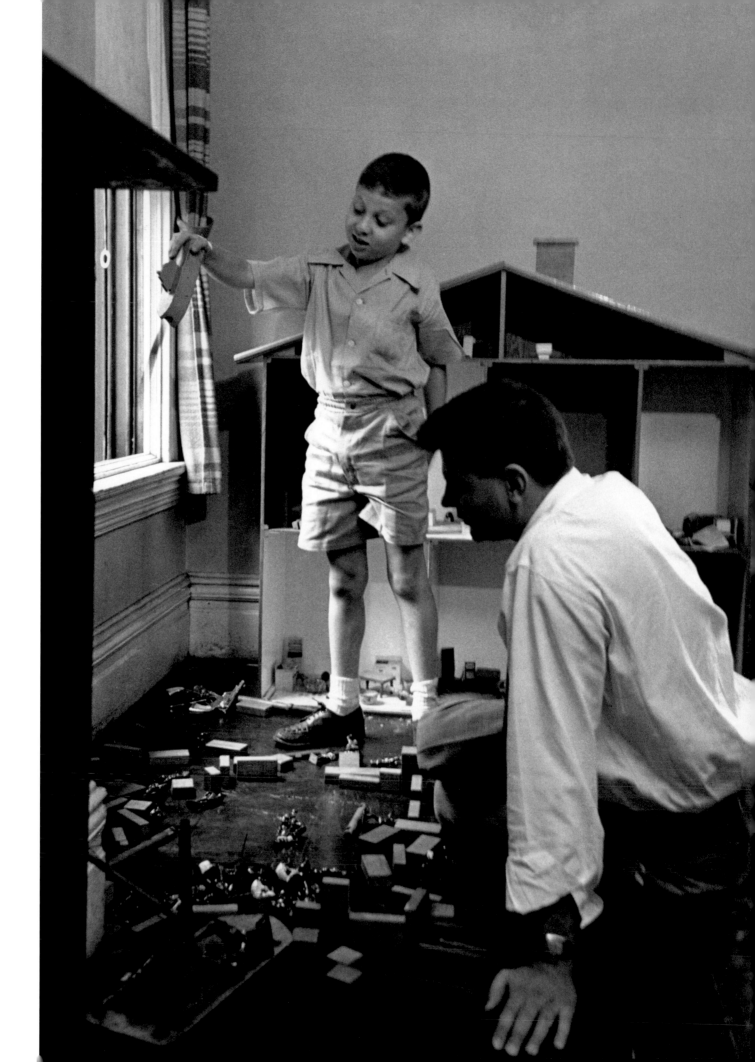

EMERGENCY TRACHEOTOMY, PITTSBURGH CHILDREN'S HOSPITAL, 1951
Pittsburgh Photographic Library

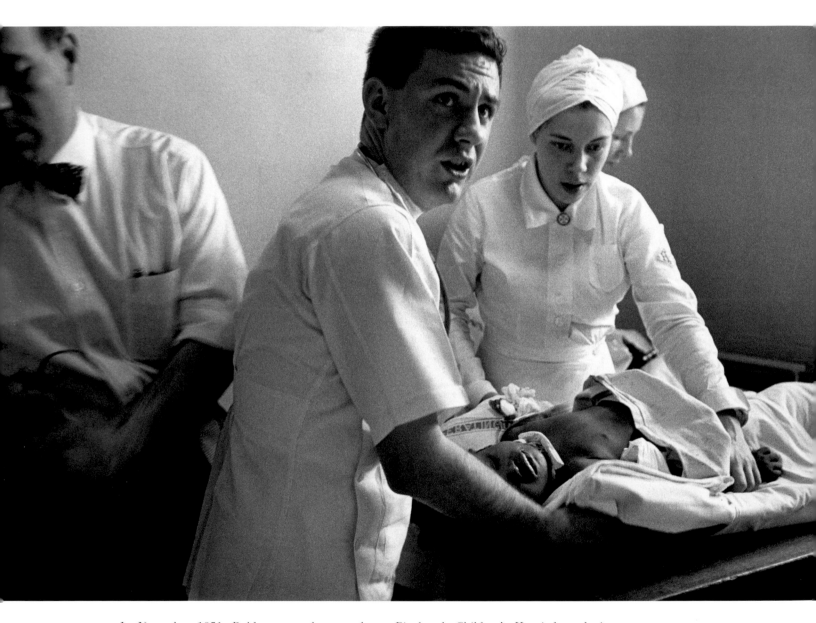

In November 1951, Bubley spent three weeks at Pittsburgh Children's Hospital producing several hundred photographs for the Pittsburgh Photographic Library. One day she witnessed an emergency tracheotomy performed in the hospital hallway. Bubley's photographs eloquently convey the life-saving event: Within minutes of the arrival of the mother and her foster child, doctors placed the child on a desk and, without anesthetic, inserted a tube in her trachea. Air rushed in and the child's chest heaved. Overcome with relief, the mother thanked the doctors and visited her child, who had been placed in an oxygen tent as a precaution against pneumonia.

This photo sequence captured the interest of Edward Steichen, who in 1952 featured thirteen prints in *Diogenes with a Camera* at the Museum of Modern Art in New York. Steichen also mounted Bubley's contact sheets to show that every frame contributed to the story.

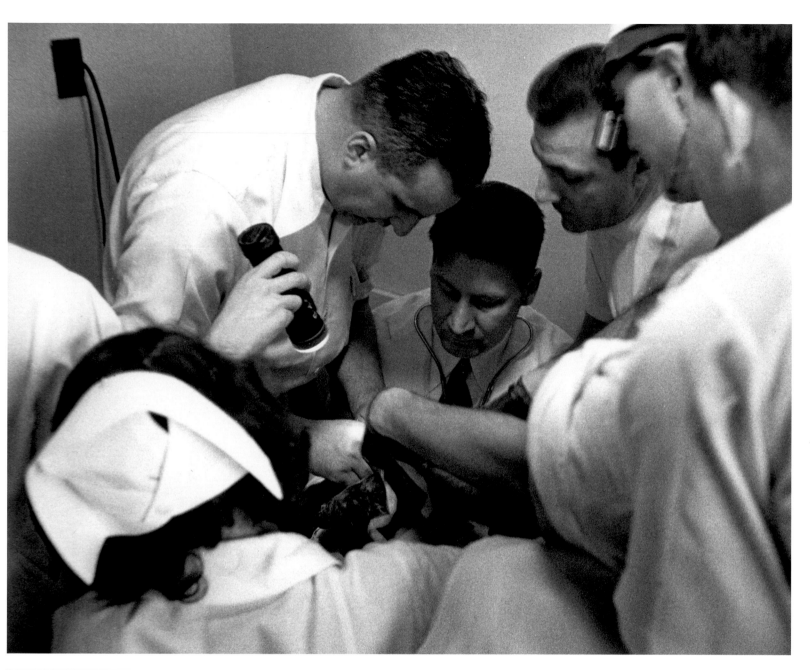

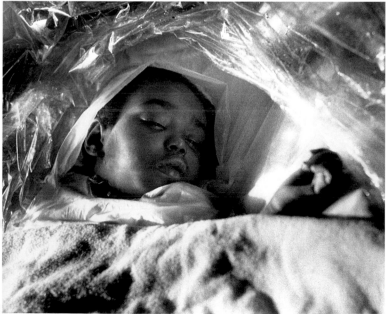

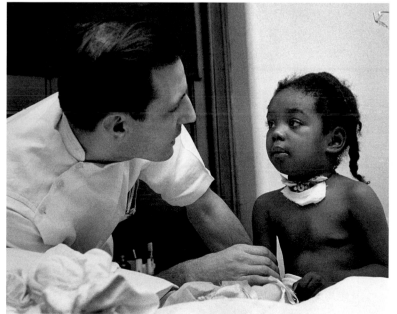

NEW YORK CITY CHILDREN
Children's Bureau, 1948

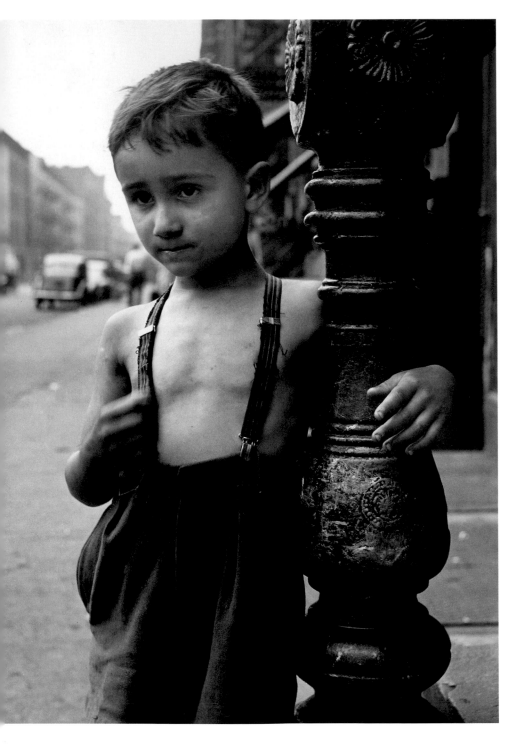

Founded in 1936 as part of the Social Security Administration, the Children's Bureau was a federal child welfare agency. Bubley contributed several thousand images to the bureau's files, and her photographs appeared on more than thirty covers of its journal *The Child*.

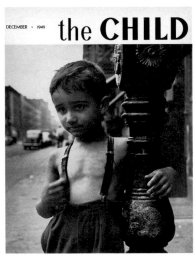

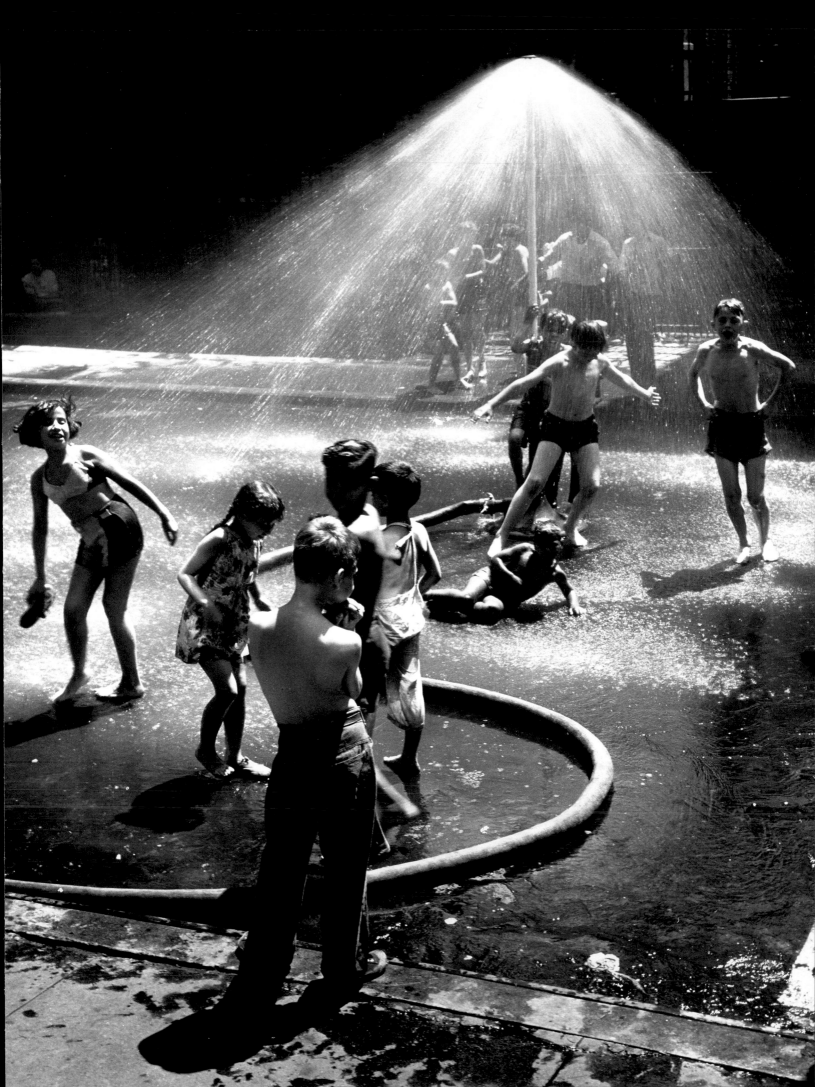

"WHAT **IS** MENTAL ILLNESS?"
Ladies' Home Journal, April 1949

From March to June 1949, the *Ladies' Home Journal* ran a four-part series on mental illness. Bubley visited two hospitals—Pennsylvania State Hospital in Philadelphia and Greystone Park Psychiatric Hospital near Trenton, New Jersey—to depict old-fashioned prison-like institutions, and also photographed a state-of-the-art facility in Anoka, Minnesota. When the articles appeared, Bubley remarked, "Illustrating the *Journal* series on mental illness [is] the most interesting assignment I've had."

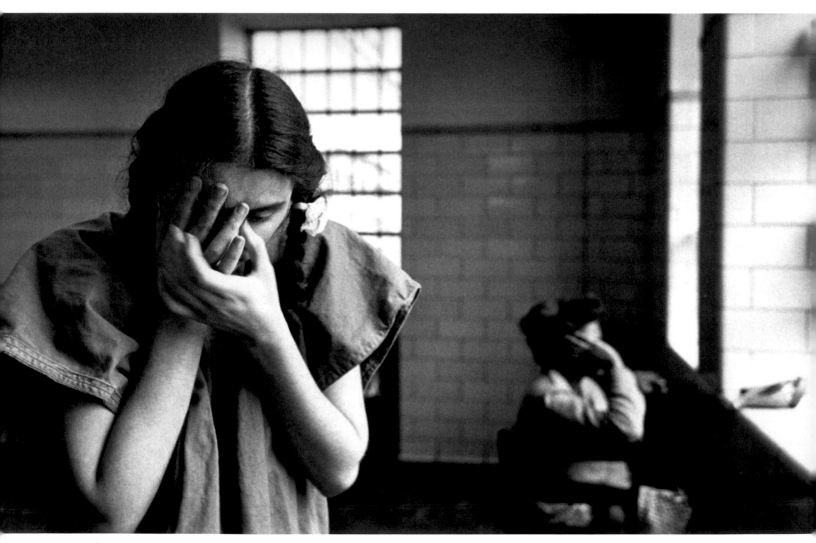

The caption for this image in *Ladies' Home Journal* read: "This woman suffers from schizophrenia. She lives in a world of her own and must be cared for in every way. She is being treated with electric shock and there is hope for her recovery." The photograph won first prize for a feature in the "News Picture of the Year" competition sponsored by the University of Missouri School of Journalism and the Encyclopedia Britannica.

"HOPE FOR SICK MINDS"
Our World, June 1951

After Bubley's award-winning photograph appeared in the *Ladies' Home Journal*, *Our World* an African-American magazine, hired her for an article on mental health. A notable difference between the African-American and mainstream press articles was the former's belief in Christian faith as well as science as a source of healing.

Graffiti in a hospital's seclusion room

RIGHT: A neglected patient in a poorly run Georgia state mental hospital

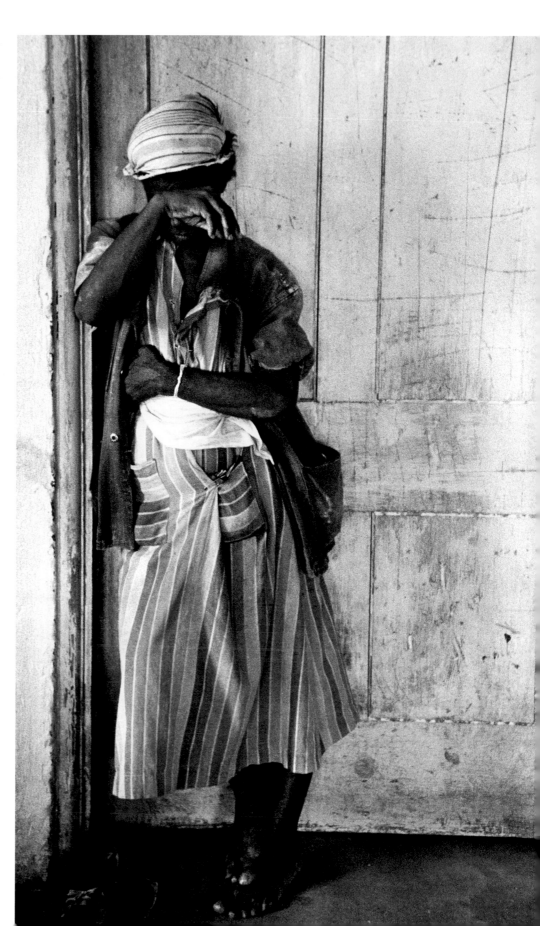

"THE ROODS' PROMISED LAND," FROM *HOW AMERICA LIVES*
Ladies' Home Journal, April 1948

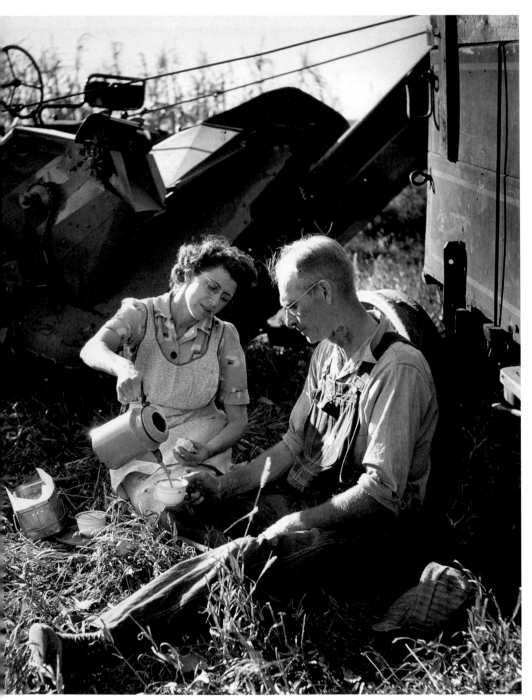

"On busy days Mrs. Rood takes lunch to her husband out in the fields. Here they are eating in the shade of the new cornpicker."

Vera and Henry Rood of Wahoo, Nebraska, were tenant farmers during the Depression. In 1940, with the help of government loans, they bought a 160-acre farm and in six years, paid off a forty-year mortgage. Bubley's photographs illustrate the Roods' new-found prosperity and the teamwork required of the six family members to achieve it.

"I'M THE HOUSEWIFE WITH 10 THUMBS," FROM *HOW AMERICA LIVES*

Ladies' Home Journal, February 1950

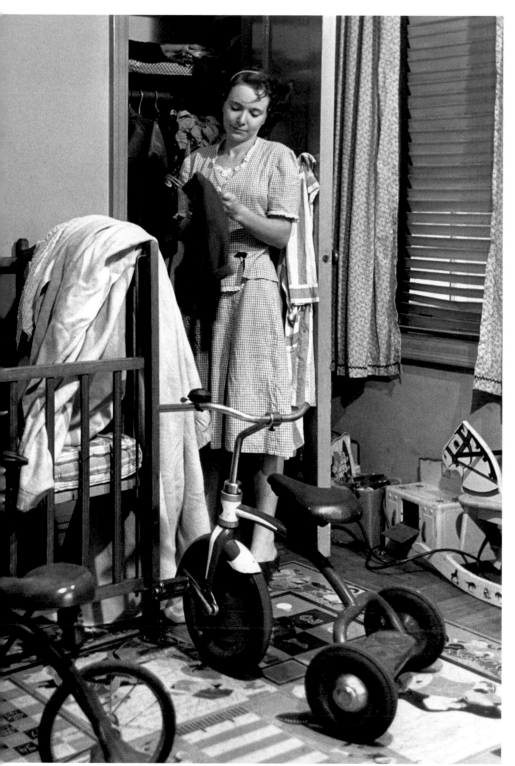

This image of Peggy Coleman picking up after her children was not published.

John G. Morris, *Ladies' Home Journal*'s picture editor, fondly remembered this story, and particularly its lead photograph:

> The housewife in New York ... to me, was a real challenge because there was nothing happening in this little apartment.... I was looking at Esther's contact sheet of the housewife ironing ... and there was one picture that stood out.... It was puzzling because she wasn't paying any attention to her ironing. And I said, "What happened there?" Esther replied, "That's when the baby cried." So that's the one I chose, because that is the housewife's decisive moment.

The housewife was Peggy Coleman, who lived with her husband Bob and their two young children in a three-and-a-half-room Manhattan apartment. Peggy was a conscientious if somewhat permissive mother, who encouraged her children's self-expression at the expense of her home's tidiness and her own schedule. The story emphasized the physical hardships of apartment living — walking blocks to pre-school, carrying laundry to the basement — and expressed the Colemans' hope that they would someday buy a suburban home.

"WHEN A BOY QUITS SCHOOL," FROM *PROFILES OF YOUTH*
Ladies' Home Journal, January 1951

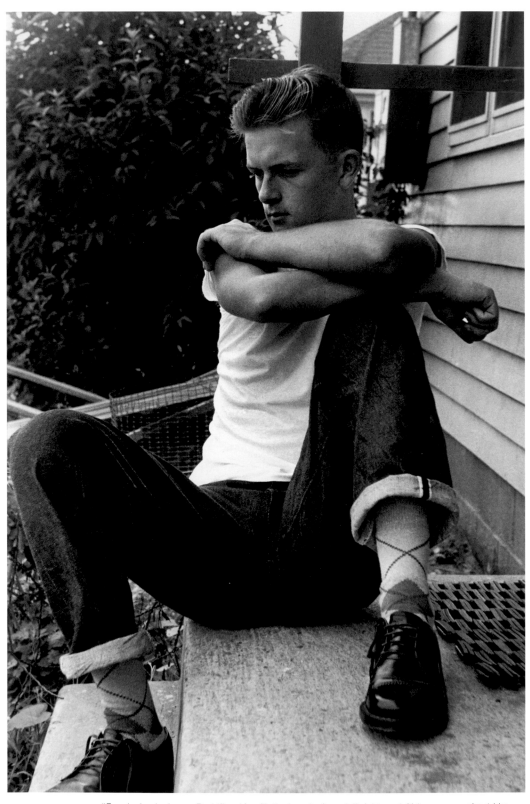

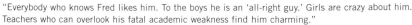
"Everybody who knows Fred likes him. To the boys he is an 'all-right guy.' Girls are crazy about him. Teachers who can overlook his fatal academic weakness find him charming."

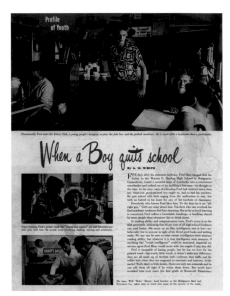

Fred Hine was a handsome, well-liked boy who could not read. He lived with his parents and his siblings in a low-income housing project in Bridgeport, Connecticut, where his high school did not provide him remedial education. At sixteen, he quit school to find a job and eventually was hired as an errand boy for a meat packing company. Pursued by adoring girls, Fred intended to postpone marriage until he earned at least $50 a week and owned his own home.

"A MIND OF HER OWN," FROM *PROFILES OF YOUTH*
Ladies' Home Journal, April 1950

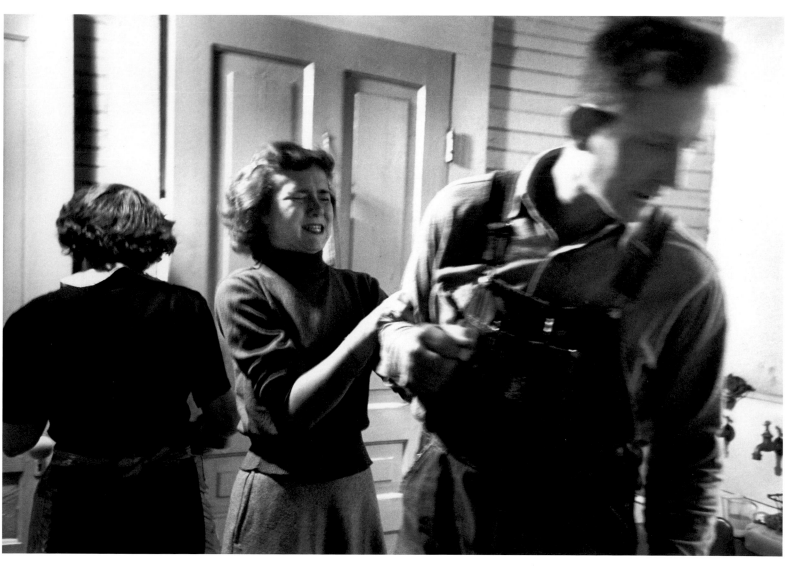

By age eighteen, Joanne Holt, of Rocky Mount, North Carolina, had "gone steady" seven times. She admitted to a "bad habit of trying like the dickens to get a boy," and then dropping him once she succeeded, but insisted that her new boyfriend, Bill Gerard "is forever — it's really different." Joanne was Bill's first girlfriend, and he liked her because she was "so vivacious and easy to talk to." Joanne shirked household chores and had little interest in schoolwork. She confessed, "Mother says she feels sorry for the man I marry. It takes understanding to put up with me."

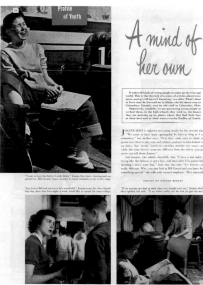

This photograph of Joanne Holt fighting with her parents, which did not appear in the article, is a testament to Bubley's ability to remain inconspicuous during her subjects' most dramatic moments.

"YOUNG HOME BUILDERS," FROM *HOW YOUNG AMERICA LIVES*
Ladies' Home Journal, January 1953

Virginia and Bob Short lived in Concord, California, a new housing development thirty-five miles east of San Francisco. The development was built for ex-servicemen, and everyone was a first-time homeowner asking the same questions: "How do you put in a lawn? How do you put up a fence? How do you build a patio?" The Shorts had one child, five-year-old "Rhubarb," and hoped for a big family "to save Rhubarb from the doom of being an only child." Written as a letter to the editor, the article accentuated Gina Short's acceptance of conformity: "How could I describe our little family? Well, we look very much like one bottle of milk standing alongside ten thousand other bottles of milk."

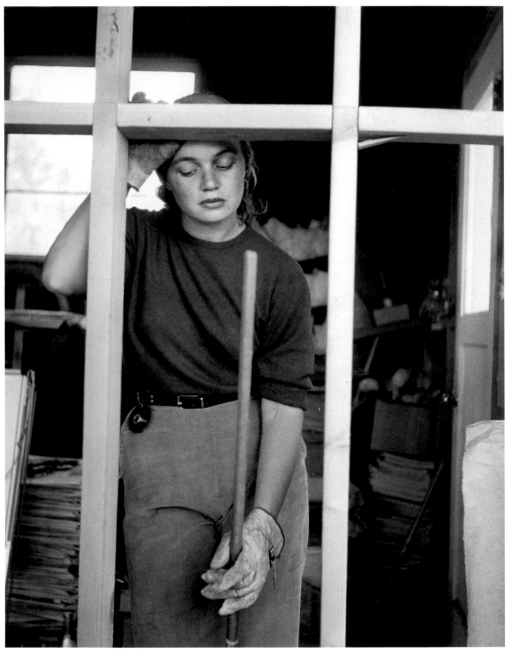

This image, not used in the article, shows Gina in the Shorts' garage, which was being remodeled as an enlarged living room and workshop.

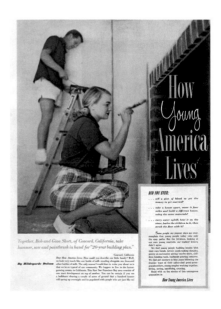

"THE PEOPLE WHO GO TO HOSPITALS"
Life, November 28, 1951

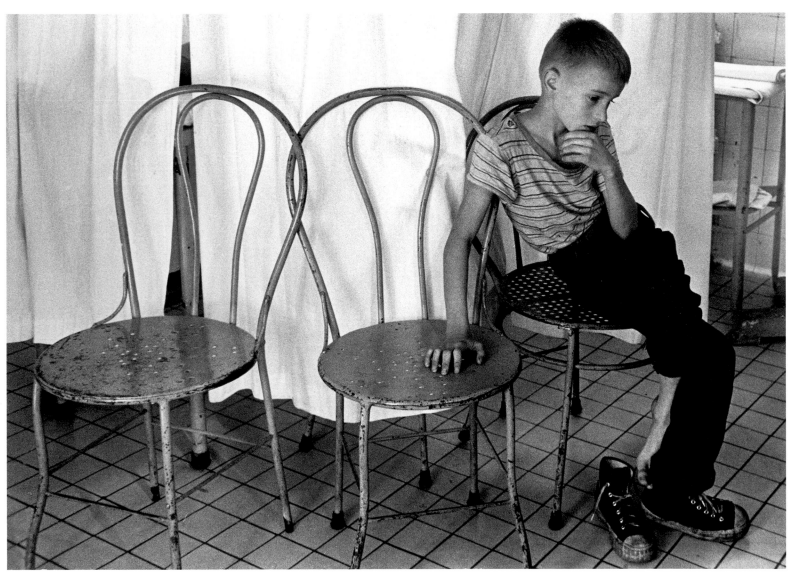

"The wait for a new bandage on an infected heel seems almost interminable to a stoic young patient."

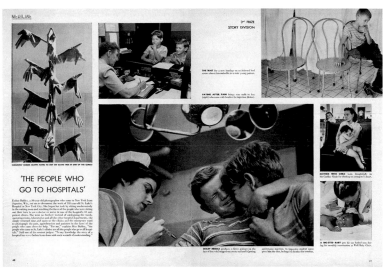

Bubley undertook her photo-essay of New York City's St. Luke's Hospital on her own initiative for *Life's* "Young Photographers Contest." Her physician, Dr. Herbert Smith, obtained permission for her to work at the hospital, which subsequently hired her for its own publications.

"CHOIR OF CHERUBS"
Life, March 26, 1951

Bubley's first *Life* assignment made the cover of the Easter issue. The magazine's introduction succinctly told the story:

On Wednesday afternoons a chorus of squealings and chirpings emerges from St. Mark's Methodist Church in Brooklyn, N.Y., and passers-by know that the regular rehearsal of the church's Cherub Choir has begun. The choir is made of 20 to 25 children between 2 and 5 years old. ... It starts practice with a few scales or rhythmic exercises. Sometimes the children sing lustily for an hour. Other times they begin fidgeting after 20 minutes. To keep them from poking and pinching each other while singing, Mrs. Cecile Jacobson, the director, makes them press their hands together in an attitude of prayer.

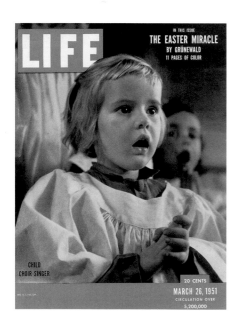

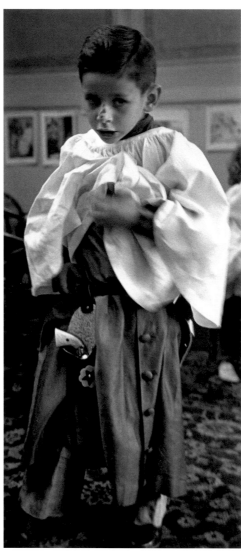

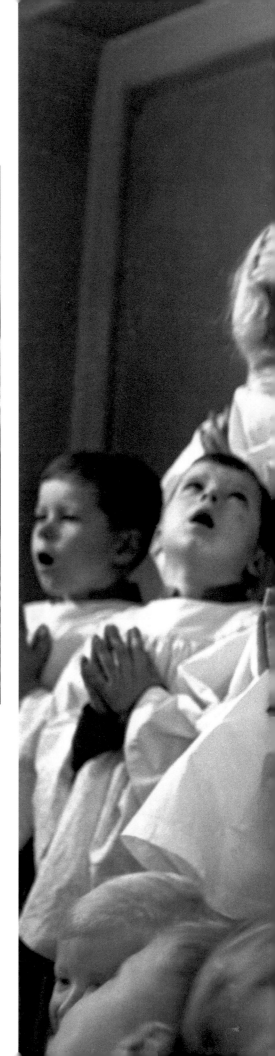

ABOVE: Jimmy Olivera kept his six-shooters handy under his surplice for the play period that followed rehearsal.

RIGHT: This image features Jimmy Olivera singing exuberantly.

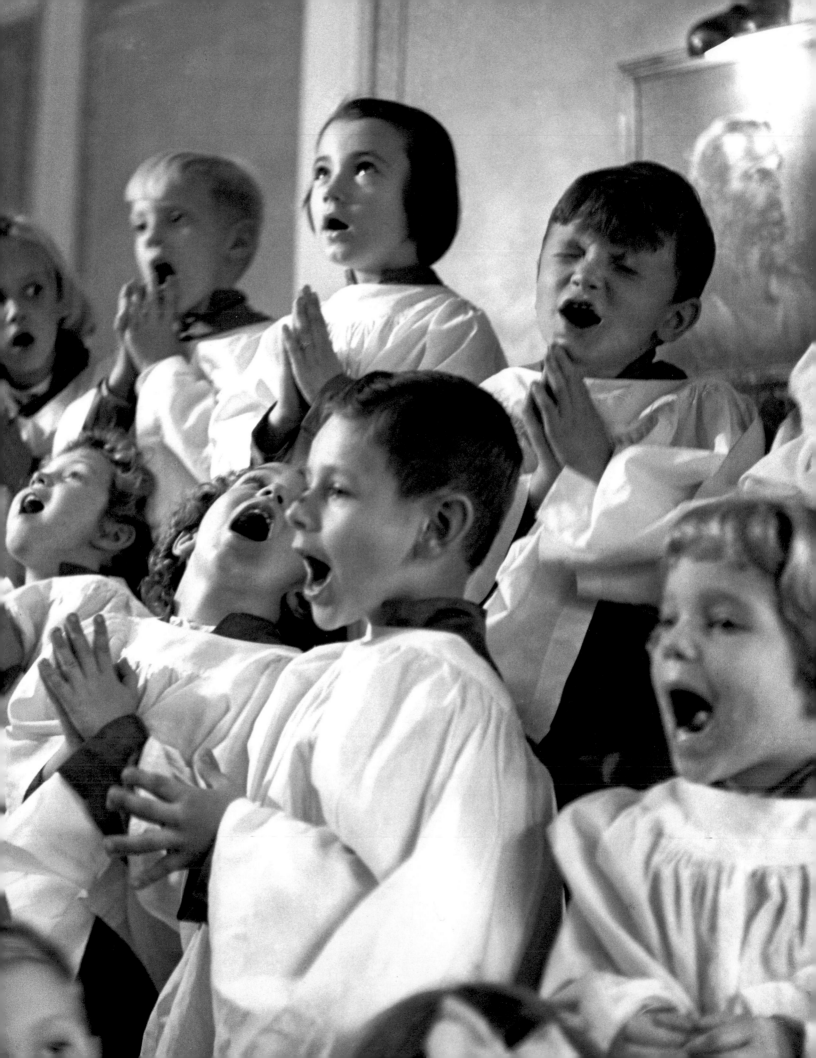

"LADYLIKE AND LEARNED"
Life, November 22, 1954

Bubley's longest photo-essay for *Life* was an eight-page spread on Cheltenham Ladies' College, England's most prestigious school for girls. As was typical, *Life* credited Bubley and did not identify the author of the accompanying text, which emphasized the school's regimentation: "Cheltenham sets its pupils in a relentless pursuit of learning and decorum, training them to be prim and correct even while off campus."

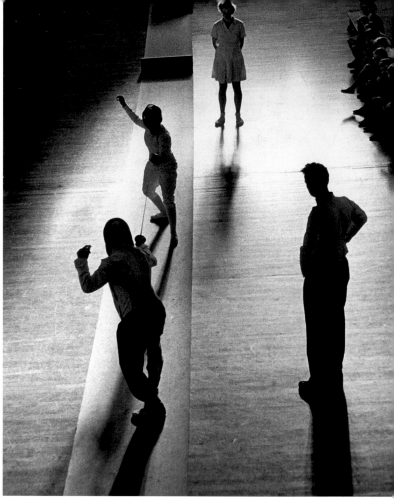

Sports were compulsory at Cheltenham.

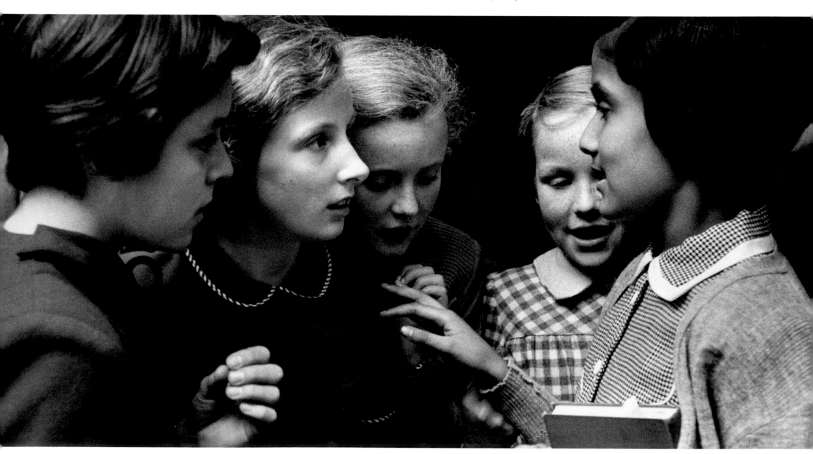

This photograph, which features an Indian student, did not appear in *Life* but was chosen by Edward Steichen for the Museum of Modern Art's *Family of Man* exhibition.

OPPOSITE PAGE: Bubley followed this girl through her very first week of school.

FOLLOWING SPREAD: After breakfast, the entire student body came to chapel for ten minutes of prayer and hymns.

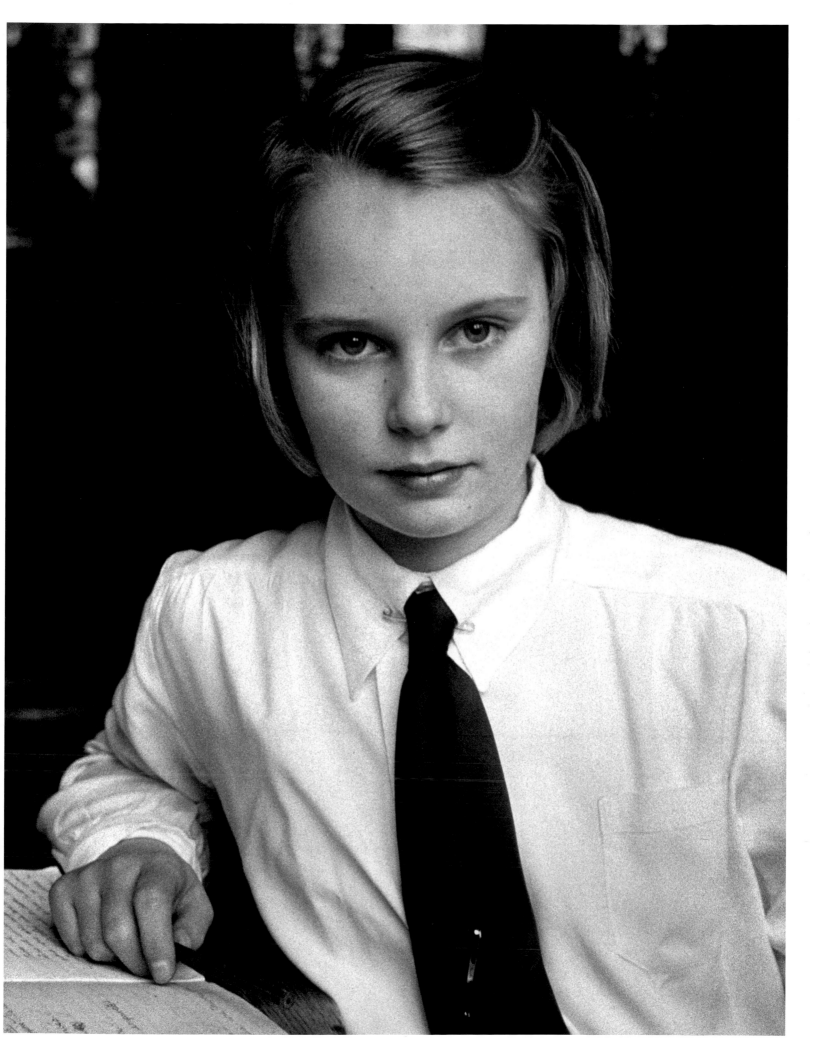

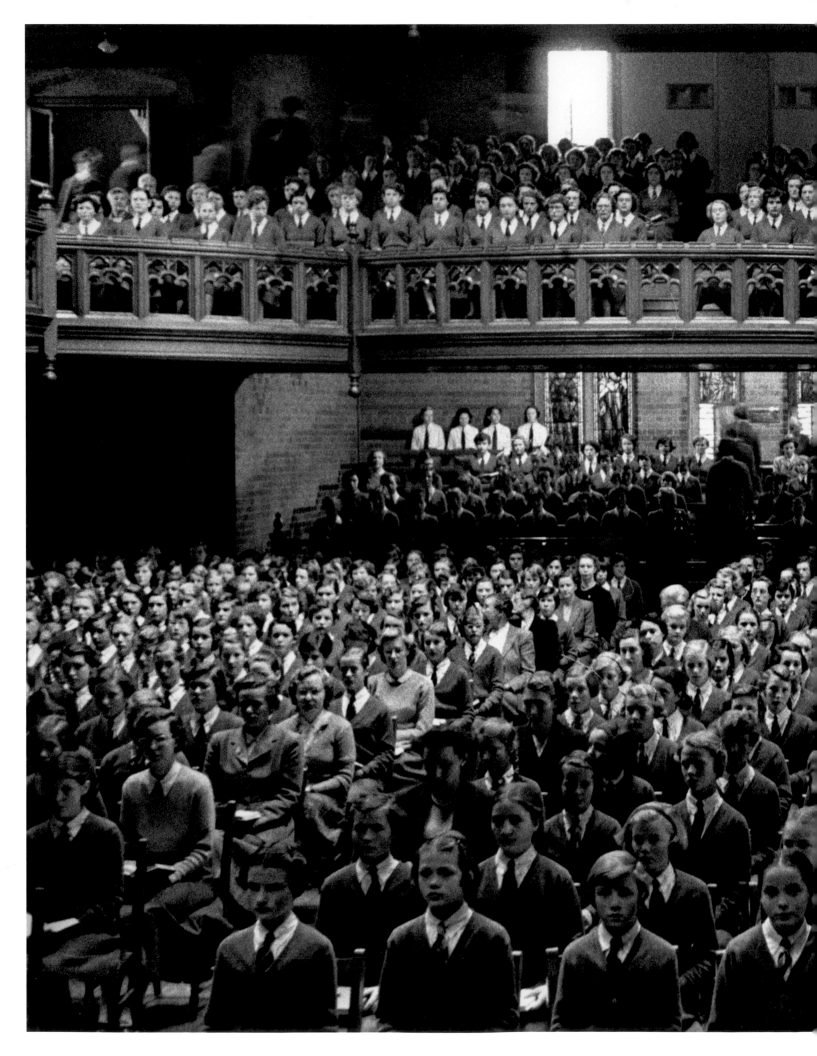

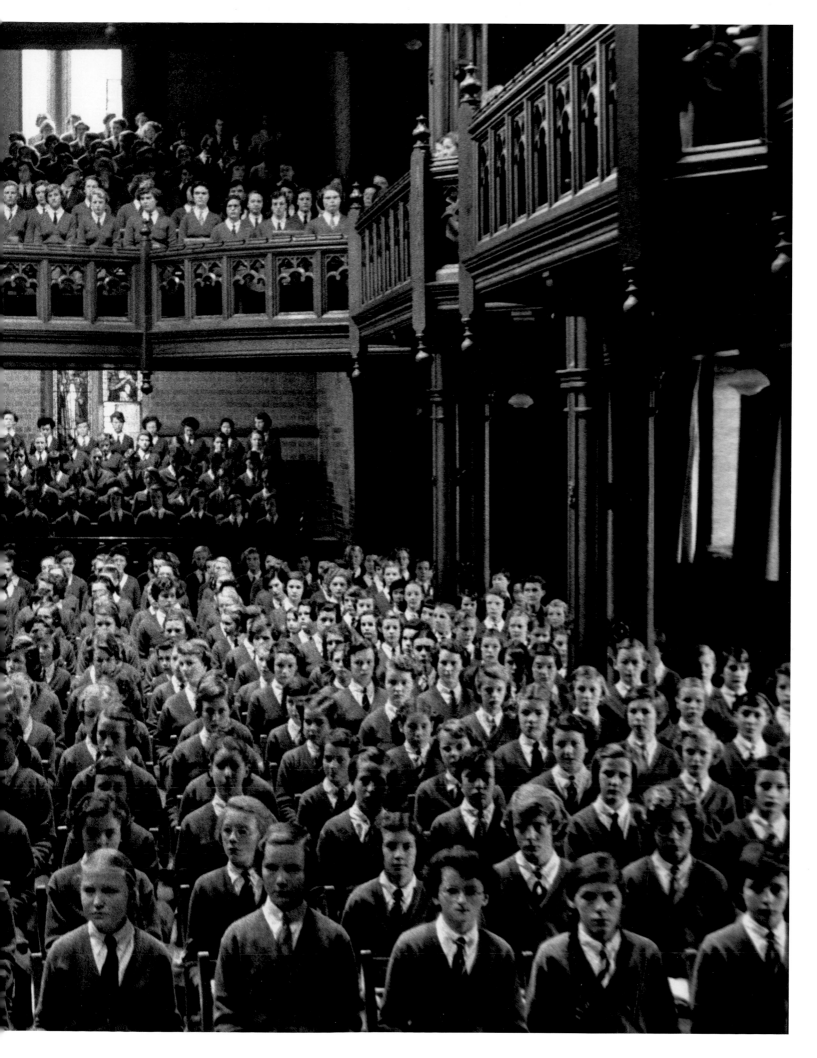

"BACKSTAGE IN QUEST TO BE MISS AMERICA"
Life, September 16, 1957

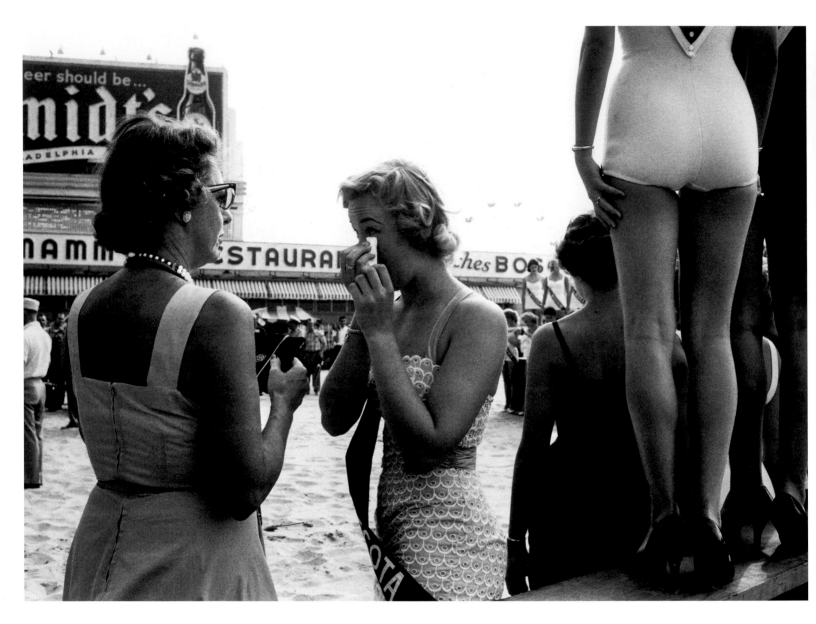

The Miss America contest, begun in Atlantic City in 1921, was first tele-
vised nationally in 1954. Bubley's photographs focused on the ordinary
and offbeat moments that occurred behind the scenes. The text offered
supporting anecdotes:

> Backstage, the girls became very sociable, exchanging addresses with
> one another. Miss Kansas gave all the other misses sunflower earrings
> and Miss Idaho gave out packages of instant mashed potatoes. But
> there were frustrations and tensions and blow ups. Miss Puerto Rico lost
> the record she was supposed to dance to. Miss Alabama lost weight and
> her clothes began to sag. Miss Oklahoma, in excitement, lost her lunch.
> At the grand finale Saturday night, despite personal disappointments,
> they all applauded warmly as Miss Colorado, Marilyn Elaine Van
> Derbur, a coed at the University of Denver, was judged the fairest of
> them all.

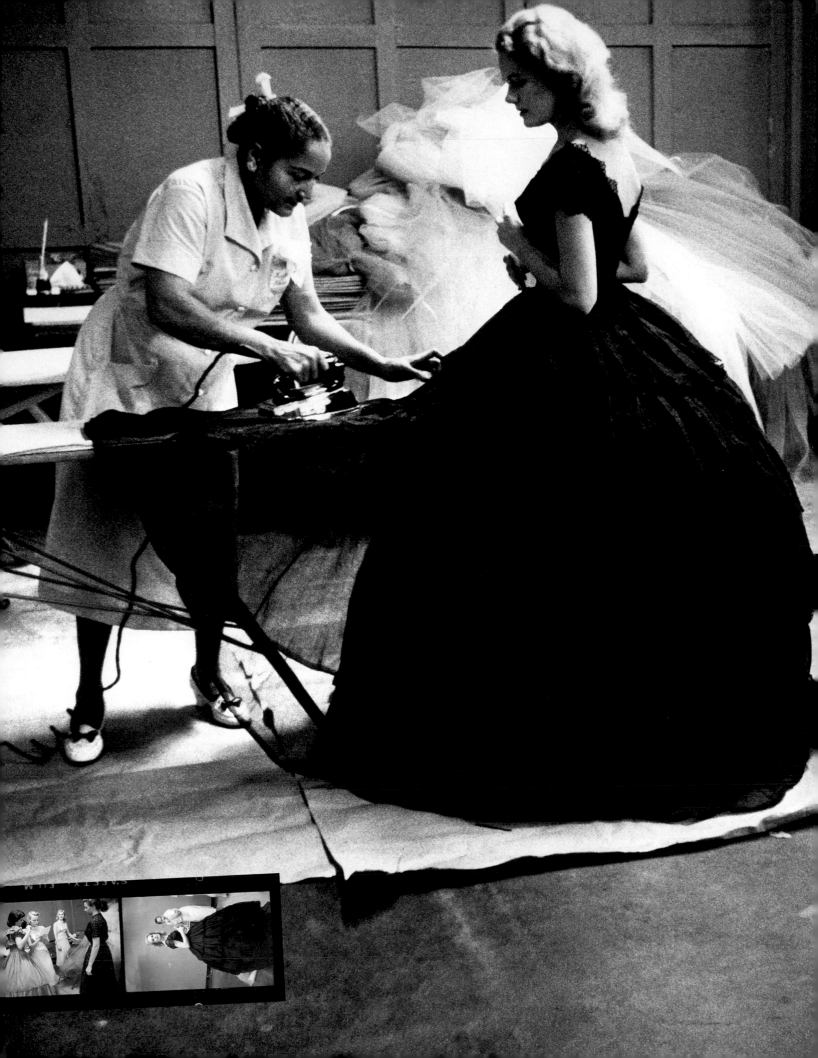

For this routine *Life* assignment, Bubley produced seventy beautiful enlargements from which the editor chose. In this case, the published story, which included none of the images shown here, failed to do justice to the photographer's treatment of the subject.

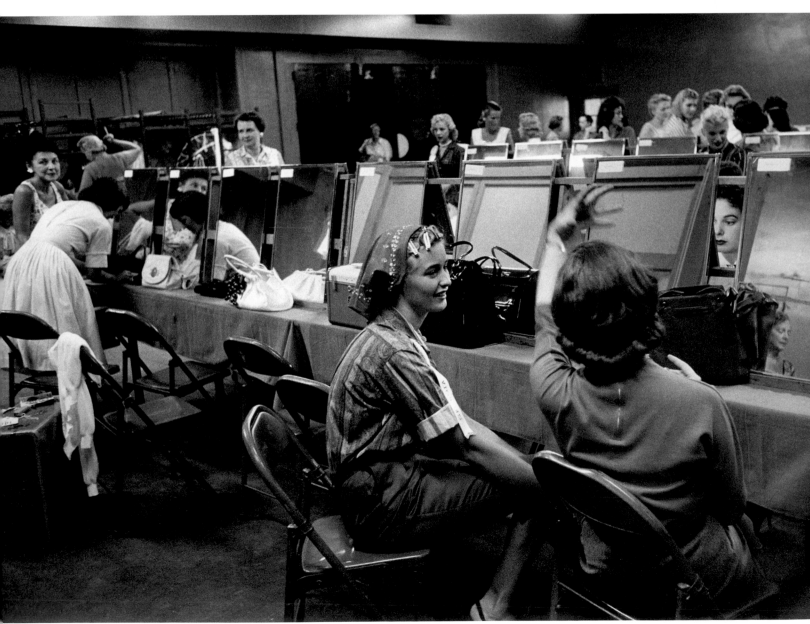

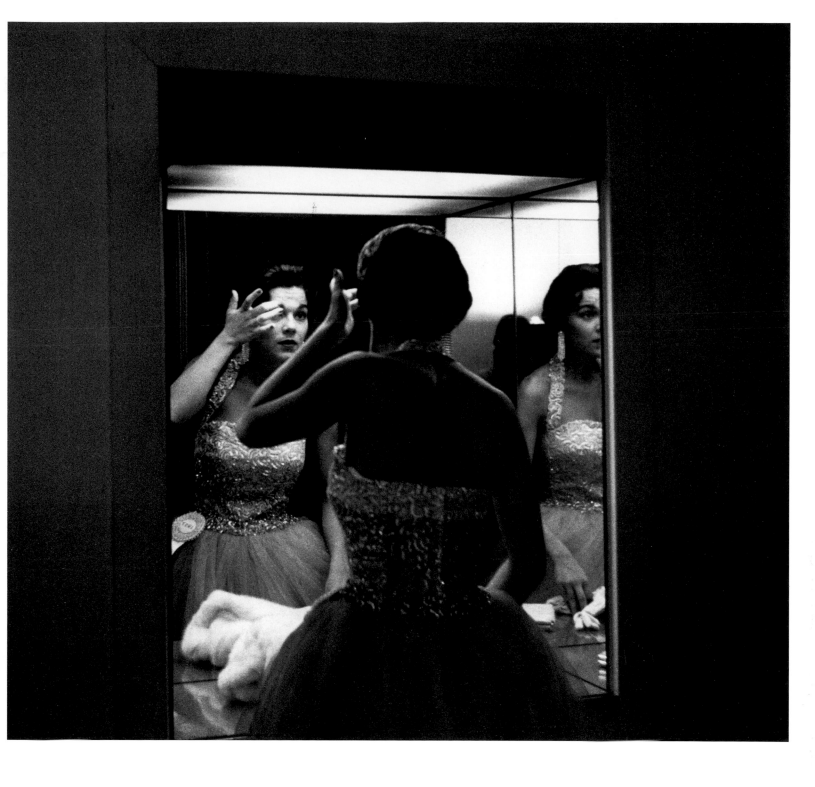

"A LOT OF FLAIR AND A COMFORTABLE PAIR OF SHOES ARE WHAT YOU NEED TO BE A FASHION PHOTOGRAPHER"

Ingenue, July 1961

Like all freelance photographers, Bubley garnered new assignments based on past successes. Her "specialty" in stories involving children and families, for example, was less the result of her own preference than of her strong showing with "How America Lives" in *Ladies' Home Journal.* This 1961 story for *Ingenue,* a magazine for teenage girls, was likely the product of Bubley's successful "behind the scenes" assignments. The article introduced the magazine's young readers to the idea of a career in fashion photography by profiling photographer Emma Gene Hall. The photographer's overalls and rolled shirt sleeves offered a droll contrast to the mink coat and floor-length gown of her model.

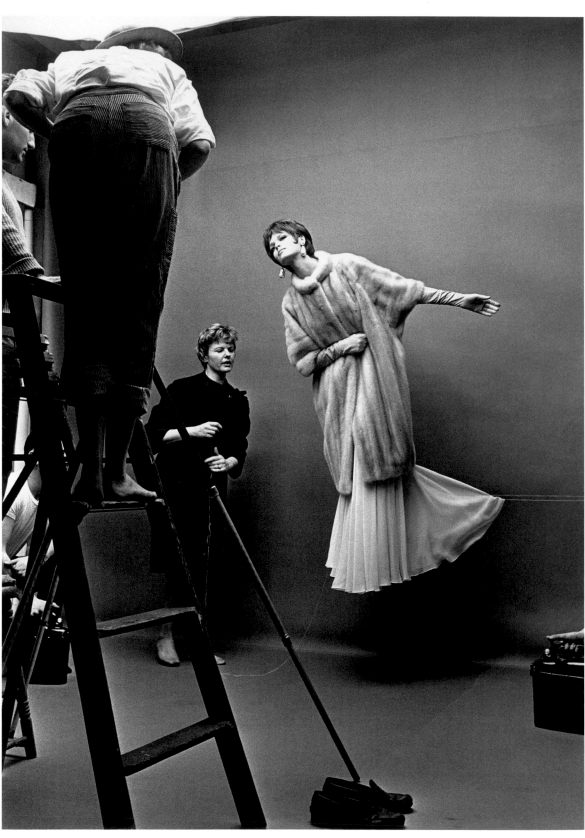

Bubley's photograph reveals that Hall preferred bare feet to comfortable shoes, despite the article's title.

"*LIFE* GOES ON A ZOO TOUR WITH A FAMOUS POET"
Life, September 21, 1953

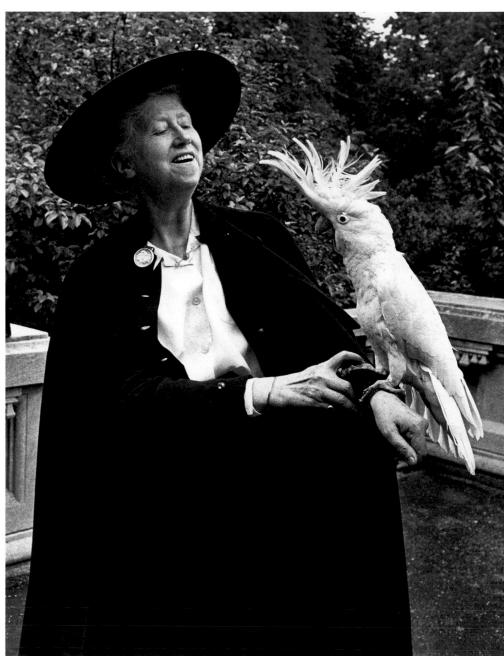

Although Bubley was best known for stories about ordinary people, she received numerous celebrity assignments. When Marianne Moore won the Pulitzer Prize in 1952, her fame spread beyond the confines of the rarified world of poetry. Her eccentric personality — a Victorian lady who loved the Brooklyn Dodgers and commercial movies — enhanced her celebrity. Her passion for animals led *Life* to enlist her for a zoo tour. The article began by noting that "recently Miss Moore paid a visit to the Bronx Zoo with Photographer Esther Bubley."

Moore and Bubley became friends, sharing visits and gifts. Normally averse to being photographed, Moore enjoyed Bubley's work, signing one request for prints, "Your fan — big and bigger." Bubley's photographs of Moore appeared in articles in French and Spanish magazines, and in 1963, *Look* commissioned her to produce the photo-essay, "Marianne Moore's Brooklyn."

"GIFT ON A 74th BIRTHDAY"
Life, March 30, 1953

One of Bubley's favorite celebrity assignments was photographing Albert Einstein on the occasion of his seventy-fourth birthday. Although frail and shy, Einstein had consented to a public birthday celebration as a fundraiser for Yeshiva University's planned Albert Einstein College of Medicine. Bubley was authorized to take only Einstein's portrait on the day before the celebration, but she persuaded him to allow her to stay longer. She photographed him at his Princeton University office, at home, and at the fundraiser. *Life's* lead image showed the rumpled scientist walking home from his office. Seemingly oblivious to his surroundings, he was recognized by a telephone company crew, who stopped to gawk as he passed by.

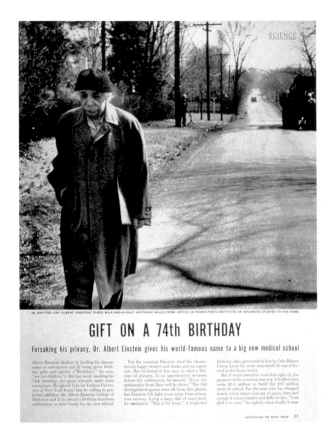

IN KNITTED CAP ALBERT EINSTEIN TAKES MILE-AND-A-HALF BIRTHDAY WALK FROM OFFICE IN PRINCETON'S INSTITUTE OF ADVANCED STUDIES TO HIS HOME

GIFT ON A 74th BIRTHDAY

Forsaking his privacy, Dr. Albert Einstein gives his world-famous name to a big new medical school

Albert Einstein dislikes 1) lending his famous name to enterprises and 2) being given birthday gifts and parties ("Birthdays," he says, "are for children"). But last week, marking his 74th birthday, the great scientist made some exceptions. He agreed 1) to let Yeshiva University of New York honor him by calling its projected addition the Albert Einstein College of Medicine and 2) to attend a birthday luncheon celebration to raise funds for the new school.

For the occasion Einstein shed his characteristic baggy sweater and slacks, put on a gray suit. But he found it less easy to shed a lifetime of shyness. In an apprehensive moment before the celebration, he mused, "Even the ambassador from Mars will be there." The 100 distinguished guests were all from this planet, but Einstein felt light years away from relaxation anyway. Eying a large slab of roast beef, he exclaimed, "This is for lions." A triple-tier

birthday cake, presented to him by Cake Bakers Union Local 51, went unnoticed (it was delivered to his home later).

But if social amenities were lost sight of, the purpose of the occasion was not: it helped raise some $3.5 million to build the $10 million medical school. For the man who has changed nearly every major concept of space, time and energy it was a complex and difficult day. "I am glad it is over," he sighed, when finally it was.

CONTINUED ON NEXT PAGE 35

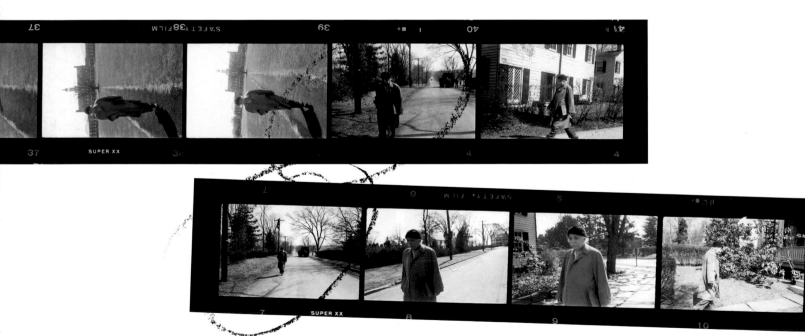

When Bubley photographed Einstein walking home from his office, she switched between two 35-millimeter cameras: one with a standard lens and one with a longer lens, which compressed fore- and background space. The lead image for the story, which showed Einstein and the telephone crew, was taken with the longer lens.

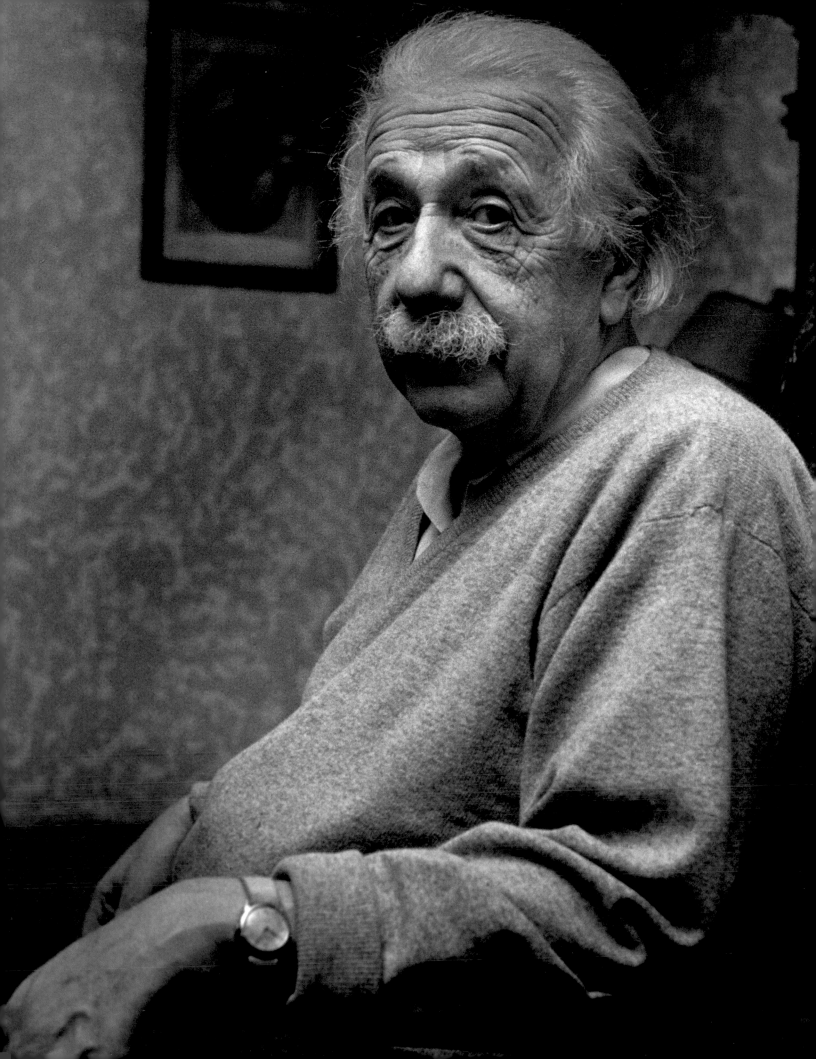

CHARLIE PARKER JAM SESSION, 1952

One of Bubley's most unusual celebrity portrait assignments occurred serendipitously. While in Los Angeles for *Ladies' Home Journal*, Bubley bumped into David Stone Martin, a graphic artist and friend, who was working on album cover designs for Clef Records. Martin asked Bubley if she would make photographic studies of what became a historic jam session featuring saxophonists Charlie Parker, Johnny Hodges, Benny Carter, Ben Webster, and Flip Phillips; pianist Oscar Peterson; trumpeter Charlie Shavers; guitarist Barney Kessel; bassist Ray Brown, and drummer J. C. Heard.

Although Bubley knew nothing about jazz, she was intrigued and willing to oblige. Working with two 35-millimeter cameras without flash and under instructions "not to get in anyone's way," Bubley produced 314 images, and remarkably none of the participants remembered her being there. Bubley sent Martin prints from which he extracted ten figures to create a montage for his pen-and-ink cover design. She also lent prints and negatives to Clef Records, which used images for liner notes without crediting her. Bubley thought little of this career sidelight until 1994, when jazz producer and author Hank O'Neal discovered the photographs and published a book of them.

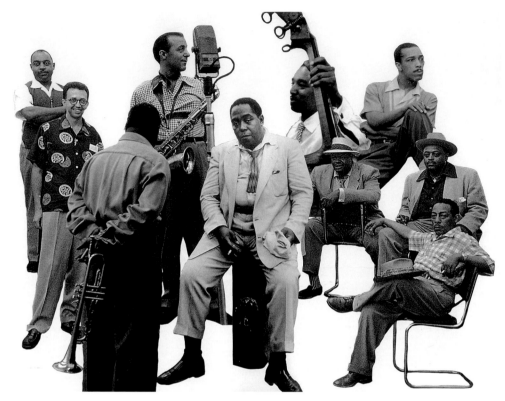

Martin used Bubley's photographs to make a photomontage (ABOVE), which formed the basis of his *Jam Session* album cover illustration.

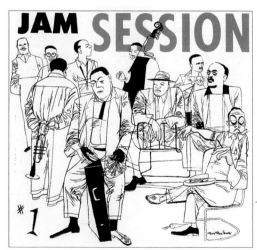

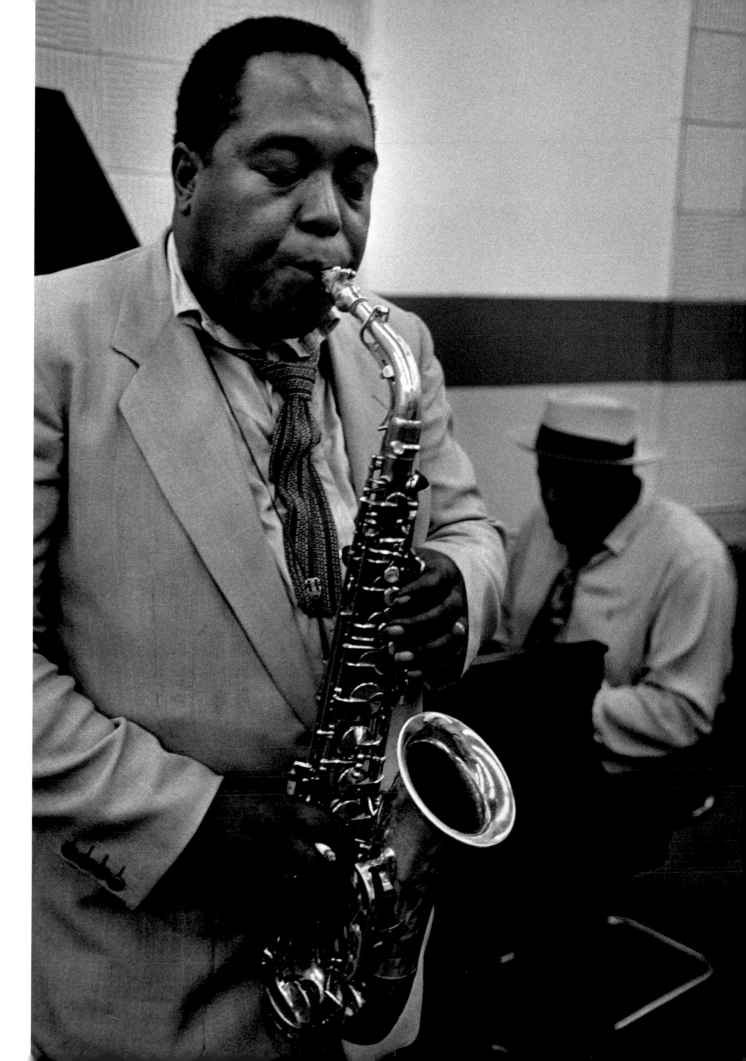

The blossoming of Bubley's career coincided with her courtship with Edwin Locke, whom she met at Standard Oil. Eleven years her senior and in the midst of a divorce, Locke was a writer who had worked as Stryker's personal assistant since the early days of the FSA. Their relationship was based on work as well as romance.

Bubley took this self-portrait in her West 47th Street apartment, where she lived from 1951 to 1954.

In the only love letter she saved, Locke discussed his hope that the New York Harbor project, which he was supervising, would "perhaps [be our] first essay at working together."[22] They were married in 1948, and Locke moved into Bubley's First Avenue apartment. The marriage quickly unraveled, however, because of Locke's chronic alcoholism, and in 1951, it was annulled. Bubley found an apartment on West 47th Street, a few blocks from Rockefeller Center and poured her energies into work.

Enduring private turmoil, Bubley took solace in the public recognition that was increasingly coming to her. In 1949 and 1950, she received first prizes in the prestigious "News Pictures of the Year" competition, which was co-sponsored by the University of Missouri's School of Journalism and the Encyclopedia Britannica. In 1951, the year she won third prize in the *Life* contest, two photo magazines published stories about her. In *Photo Arts*, Morton Reif contrasted Walker Evans' documentary style, which he characterized as "forced and lacking in the indigenous qualities of American life," with Bubley's, which he felt "encompasse[d] a record of happy people in settled mores."[23] In *Modern Photography*, John R. Whiting wrote an in-depth biographical essay and offered more discerning comments on her work: "She is not reporting how the lower-middle-brows live for the eyes of Greenwich Village or Radio City. She is reporting a much larger picture of American life — for a much larger audience."[24]

Bubley also won the admiration of the legendary Edward Steichen, who directed the photography department at the Museum of Modern Art from 1947 to 1962. During these years, MoMA was the only New York museum committed to showing photography, and Steichen, who never organized one-person exhibitions, included Bubley in three group shows in four years. In 1948, he showed ten Bubley photographs in *In and Out of Focus*, an exhibition which toured Europe for a year. In 1950, he included Bubley among *Six Women Photographers*,

along with older artists Dorothea Lange and Margaret Bourke-White and younger talents Tana Hoban, Helen Levitt, and Hazel Frieda Larson. And in 1952, he featured sixty of Bubley's Pittsburgh Children's Hospital photographs in *Diogenes with a Camera*, alongside works by Edward Weston, Frederick Sommer, Harry Callahan, Eliot Porter, and W. Eugene Smith. Bubley was also represented in Steichen's magnum opus, *The Family of Man* (1955), which traveled the world and became the most popular exhibition in the history of the medium.

In 1952, Bubley traveled to Europe for Standard Oil to complete an Italian version of "Bus Story," the first of many international assignments. The trip expanded her horizons, as this journal entry from Rome indicates: "I think that the wonderful thing that is happening or has happened to me is that I am growing up, or I am grown up and enjoying it. I have joined the human race. It is like finding one's family at last." Bubley found in the art of the Italian Renaissance — art made by great craftsmen for powerful patrons — an answer to doubts about her own artistic status as a commercial photographer:

> *I have no more silly questions about what is art or why is art. Seeing the great works of the Italian Renaissance has answered them. Why do I do what I do — that used to bother me — no longer. I am quite humble and happy to be one of those people who work because they love their work and take pride in doing it as best they can. There is no difference in whether this work is making a dress, painting a picture or sculpture or photography. That is a thing which America lacks — the pride of craft.*[25]

For the next dozen years, Bubley spent as much time abroad as she did at home, working for magazines and corporate clients. A letter of April 5, 1954, to Stryker captures her excitement with globetrotting:

> *I got home yesterday from another trip to Europe … I'm really beginning to feel like a transoceanic commuter. I left New York last October, did a story in England for* Life, *spent four weeks in Morocco on a UNICEF story, then went to Spain and Tangier and back to Italy where I did one story for* Life *and one for Esso — spent Christmas and New Years in Paris and came home feeling that I had done enough traveling to last me for several years; only to walk into Mackland's office and have him say, "Good God — you're the last person I wanted to see come in — we have a story for you in Germany and have been hoping you'd get our message and stay." Well, I was quite disappointed since it was a nice sort of thing — to do a long story on the life of a German working girl — and I was very curious about what's going on there anyhow. The upshot of it was that they agreed to hold the story for me, and I got a couple of assignments in Denmark to do for the* Lamp *so off I went again. I'm glad I went even though at this point I've seen so much that my impressions aren't very impressive but I trust I'll get myself sorted out eventually.*[26]

THIRD AVENUE ELEVATED TRAIN, NEW YORK CITY, ca. 1951

During the 1950s, most of Bubley's assignments required black-and-white photography, but she occasionally found that color best fulfilled her personal vision. In the early 1950s, for example, she used 35-millimeter slide film to study the Third Avenue elevated train, Manhattan's last El, which was torn down in 1955. Photographing inside the cars, from the platforms and on the street, Bubley embraced a subject that was technically challenging but rich in design and human interest.

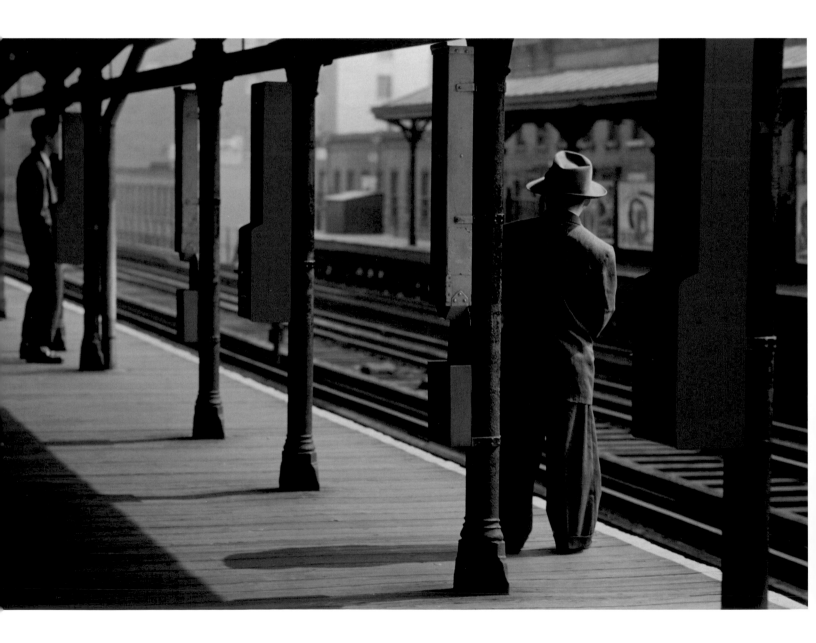

Bubley took this photograph on June 15, 1951, the day after the Brooklyn Dodgers beat the St. Louis Cardinals, 2-1, and the New York Giants beat the Cincinnati Reds, 11-6.

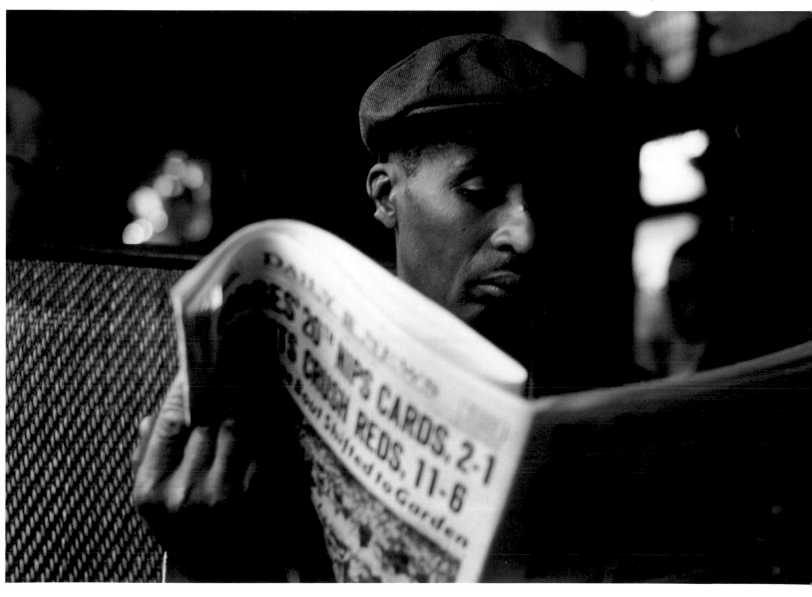

This view from beneath the El was taken at Third Avenue and East 43rd Street.

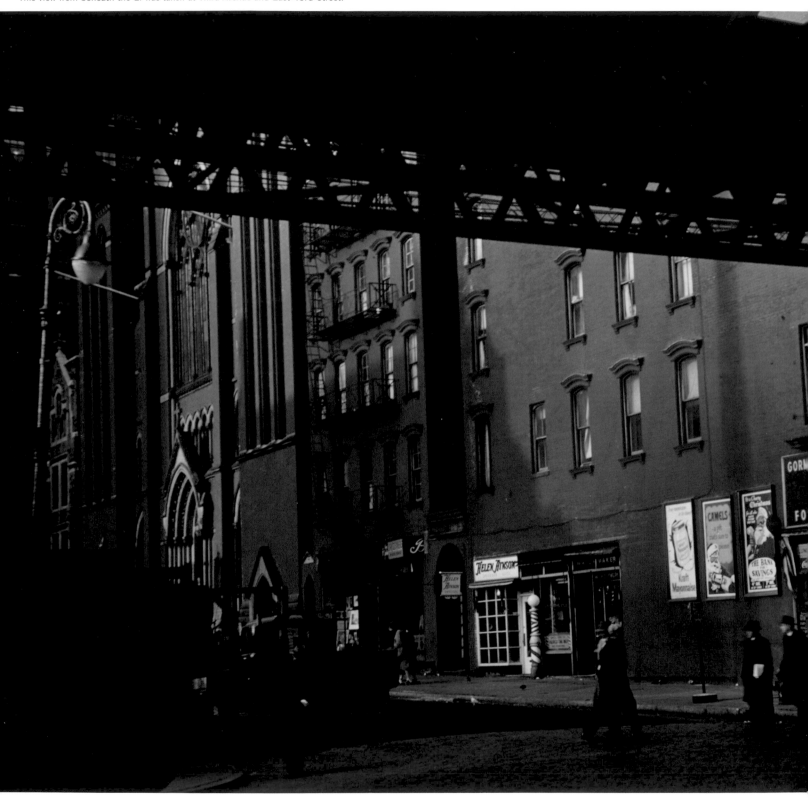

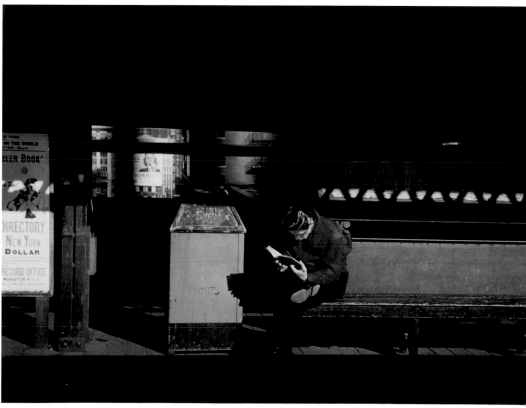

MATERA AND SASSO, ITALY, 1954
Standard Oil Company (New Jersey)

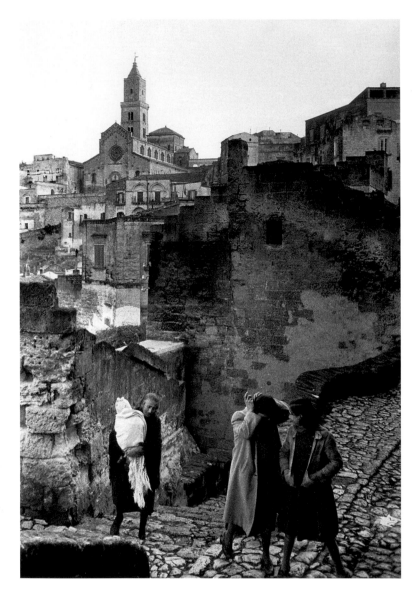

On her second trip to Italy, Bubley photographed the southern city of Matera, which offered a striking contrast between the ancient and modern. Within the city were the Neolithic cave dwellings of Sasso, which housed 15,000 people; outside it was the nearly completed St. Julian Dam, designed to irrigate 9,000 acres of farmland. At the time of Bubley's visit, the caves had been declared unsafe, and the residents were being evacuated and resettled in a modern housing development.

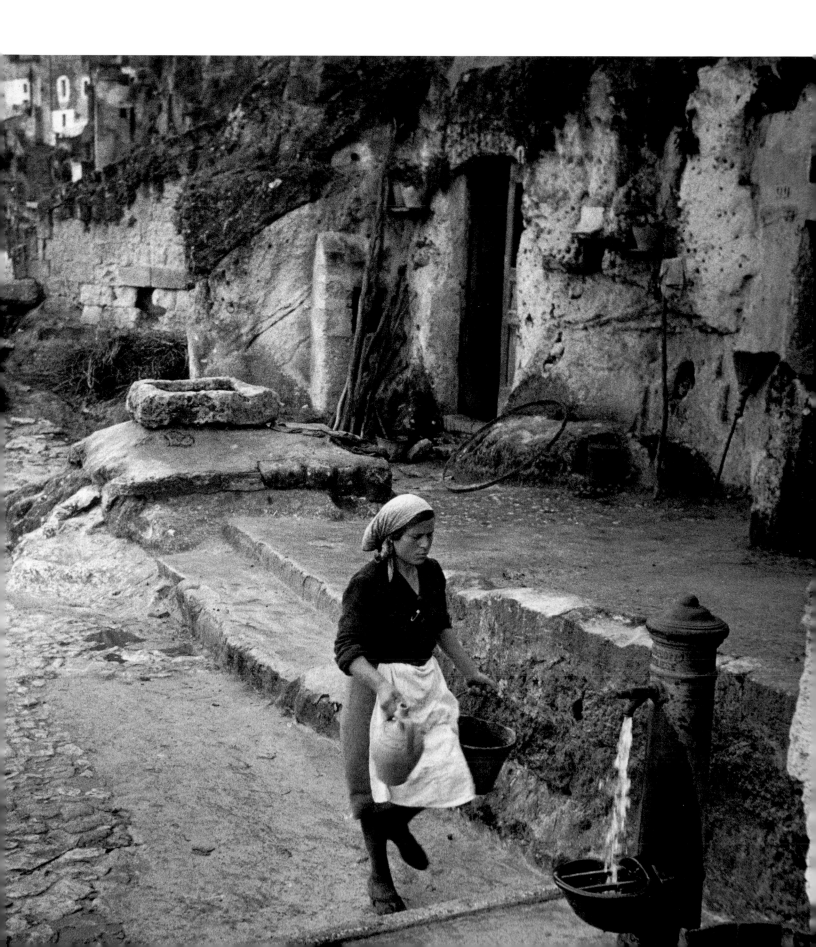

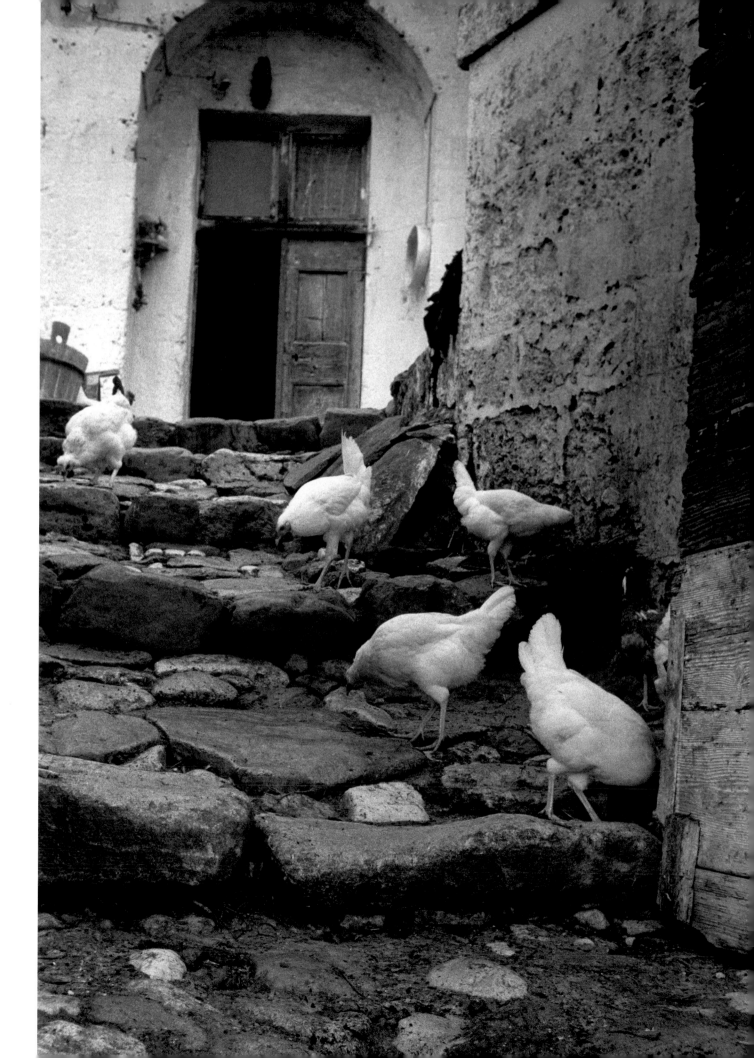

TRACHOMA CAMPAIGN, MOROCCO, 1953
United Nations International Children's Emergency Fund (UNICEF)

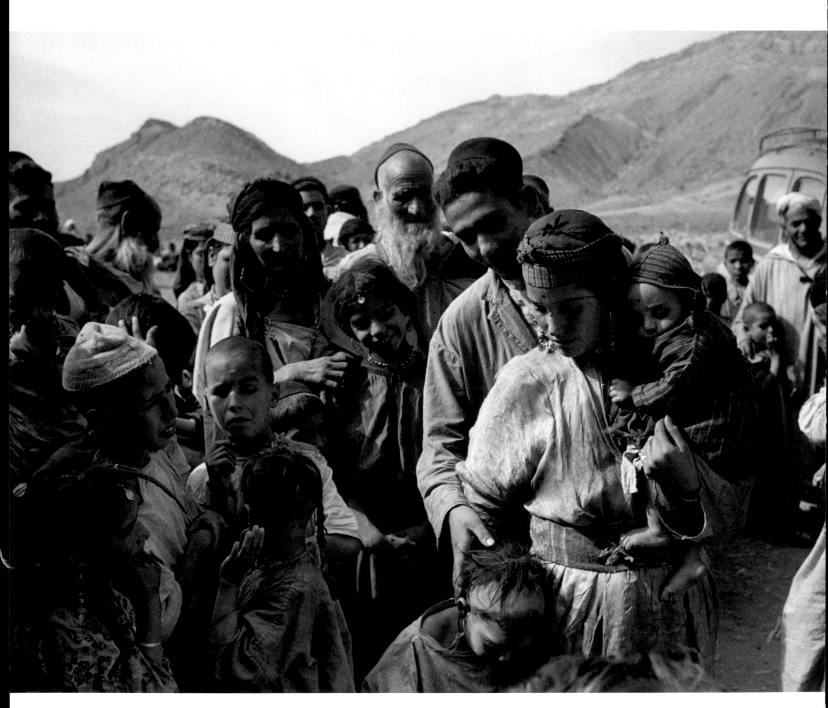

In November 1953, Bubley accompanied a team of French public health workers to a remote valley cut off by the Atlas Mountains and the Sahara Desert, where temperatures ranged from 100 to 125 degrees and flies and sandstorms clouded the air. The doctors' mission was to administer antibiotics to an isolated Berber community, which had for centuries been afflicted with trachoma, an eye infection leading to blindness. At the time, the disease affected 100 million people worldwide.

Bubley's photographs of the pioneering mission appeared in UNICEF publications and several commercial magazines.

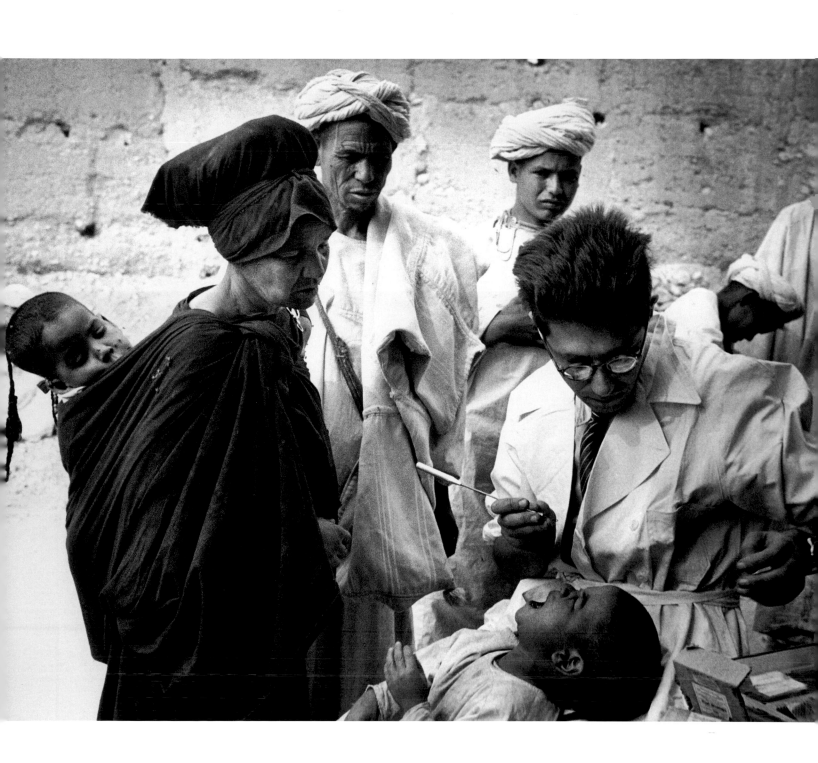

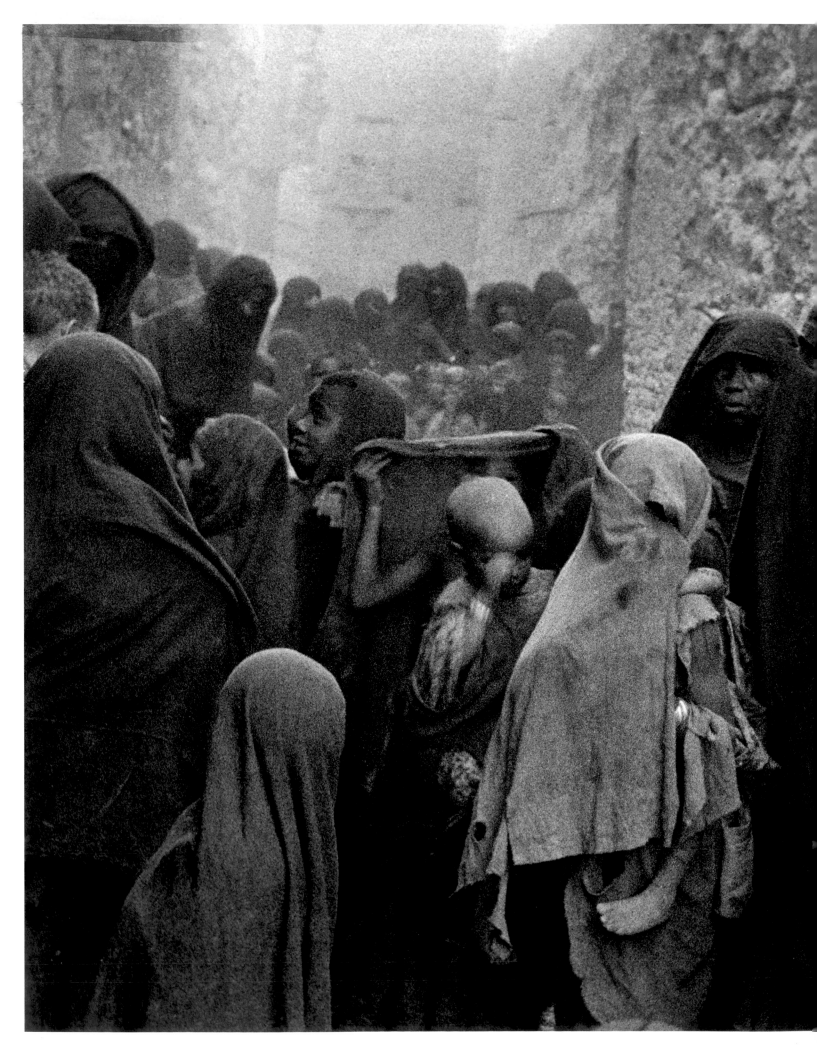

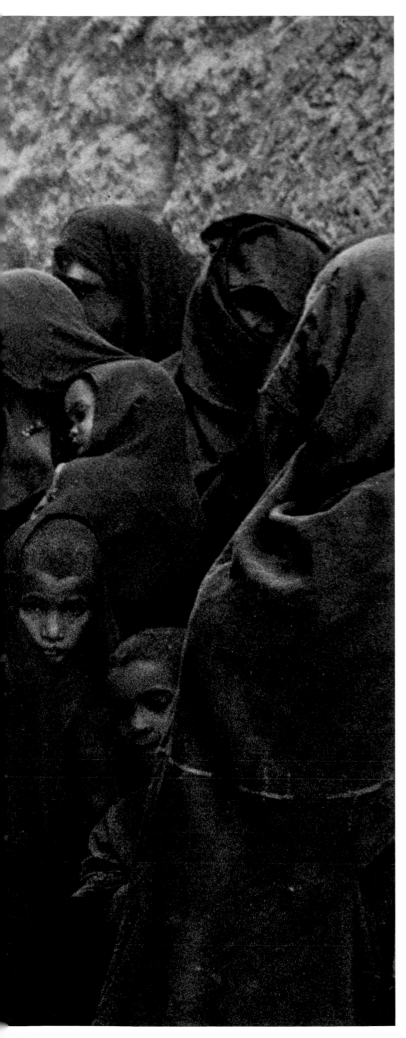

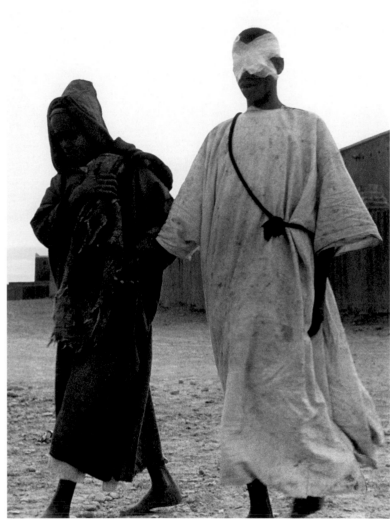

Surgery was the only hope for advanced trachoma victims. The UNICEF medical team traveled with a mobile surgery unit, in which this patient received treatment.

This photograph, which shows Berbers waiting for treatment, won the $2,000 first prize in a 1954 *Photography* magazine contest.

In 1956, Bubley accepted an offer from Pepsi-Cola International to travel to Latin America. Challenging the hegemony of Coca-Cola, Pepsi had launched an ambitious international initiative, opening eighteen new bottling plants on six continents.

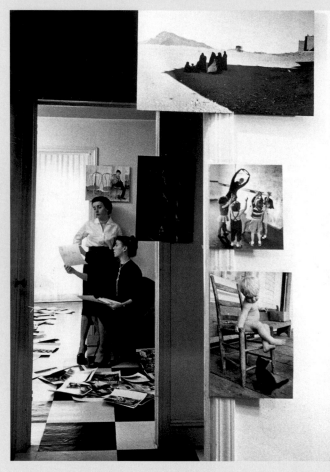

In this dual portrait, Bubley and Sally Forbes are seen working on an exhibition in Bubley's apartment at Broadway and West 56th Street, ca. 1957.

To publicize its efforts, the company founded *Panorama, a Magazine of Places and People*, a multi-lingual, bi-monthly journal "in which top-caliber photography [was] used to further understanding and friendship among individuals and nations."[27] Bubley, Ted Castle (who covered Europe and Africa) and Bern Keating (who covered Asia) were the principal photographers. In two years time, Bubley traveled to every country in the region except a handful of Caribbean islands, photographing topics as varied as an airport in Brazil, farming in El Salvador, a Mayan ritual in Guatemala, and an oil refinery in Aruba. *Panorama* won an Art Directors Club award in 1958 for an issue featuring Bubley's story on a circus in Bogotá, Columbia. In a promotional essay about Bubley, Pepsi-Cola exclaimed, "It's a man-size undertaking, but not for a girl who has demonstrated often that it's no longer a man's world."[28]

In addition to her corporate work, Bubley also led the way in the short-lived vogue for "documentary advertising." Her technique of photographing people candidly in natural settings was perfectly suited for an advertising trend that used ordinary people instead of professional models.

In 1956, Bubley produced seven photographs for a Security Mutual Life Insurance Company campaign representing "the seven ages of man." Like the enormously popular 1955 exhibition *The Family of Man*, the campaign imbued candid photographs with symbolic significance: the image of a newborn was entitled "recognition"; that of a teenage couple, "prelude"; and that of an elderly woman "bravery." On seven consecutive Sundays, the company ran a different full-page image in the *New York Times Magazine* and subsequently published the series as an oversized portfolio. The portfolio's text, which included Bubley's portrait and biography, lauded her:

> *To find humanity, to project humanity in its messages, Security Mutual has in past years sought out the best artists in a variety of media…. But no previous campaign, we feel, equals the 1956 series of advertisements shown in this portfolio. They employ some of the best, the most warmly*

*human photographs ever created for an advertiser. The
photographer who created them is Esther Bubley.*[29]

The campaign inspired a similar assignment from the John
Hancock Mutual Life Insurance Company, and both projects
won Art Directors Club awards.

In the early 1950s, Bubley began to develop a professional
relationship with Sally Forbes, a close friend whom she had
met in 1945 at Standard Oil, where Forbes was the photograph-
ic librarian. In 1957, Forbes left Standard Oil to work
for ten years as Bubley's representative, organizing her files,
soliciting and managing assignments, handling her correspon-
dence, and planning parties for friends and business associates.
Among Forbes' responsibilities was hiring models for advertise-
ments, and some of Bubley's most successful ads featured
Forbes' own family. In 1957, for example, *Time Magazine*
launched a campaign entitled "The Need to Know" with a
photograph of two-year-old Philip Forbes climbing a tall
bookcase to reach a favorite book. And in 1960, the Scott
Paper Company used a photograph of the Forbes family at
breakfast in a campaign that earned Bubley another Art
Directors Club award.

Forbes also organized Bubley's photographs for many
one-person and group exhibitions. In 1956, Helen Gee showed
Bubley at the Limelight, her Greenwich Village coffeehouse
whose monthly exhibitions were a must-see for New York
photographers. In 1960, Bubley's work was exhibited in the
Hudson Branch of the New York Public Library, another popu-
lar Greenwich Village venue. In 1956, 1958, and 1959, Bubley
had three exhibitions at Rockefeller Center, and in 1959, edi-
tors and writers polled by the *National Photographer* named
her one of the nation's ten outstanding women photographers.
In 1960 and 1965, Bubley's works were included in Ivan
Dmitri's exhibitions *Photography in the Fine Arts*, which sought
to promote photography in art museums, and in 1965, she was
shown in the Smithsonian Institution's *Profile of Poverty*.
Bubley continued to work for numerous magazines — *Life,
Look, Ladies' Home Journal, Woman's Day, McCall's, Saturday
Evening Post, New York Times Magazine* — but the rising
popularity of television was usurping the audience for picture
magazines, and her career cooled.

In 1964, Forbes secured a major commission for Bubley
from Pan-American World Airways. The company was expand-
ing its service internationally and proposed "a top-drawer photo
library for the Pan-Am Public Relations Department," modeled
on the Standard Oil Library. Bubley traveled for eight weeks
photographing in New York, London, Frankfurt, Turkey, Iran,
India, Lebanon, and Afghanistan. In early 1965, she
photographed the Guided Missile Program at Cape Kennedy,
Florida, and in the fall, she traveled for three months to
Hawaii, Australia, New Zealand, the Philippines, and Southeast
Asia, including Saigon, where Pan-American was a carrier for
the United States military. Bubley's mission was to photograph
the staff and equipment of the company and to provide an
inventory of human interest stories for advertisements and
for Pan-Am's corporate magazine, *Clipper.* Informed of her
itinerary, Standard Oil hired her once again to photograph for
the *Lamp.*

The two around-the-world trips were grueling and lonely,
and although Bubley produced strong work, very little was
published. The most extensive presentation was a 1966
exhibition of one hundred prints in *Esther Bubley: The
Selective Traveler* at the Eastman Kodak Gallery in Grand
Central Terminal. That year, Bubley accepted her last travel
assignment — Irish International Airlines sent her to Ireland
for three weeks, paying her the lavish sum of $10,000. She
was tired and had had enough.

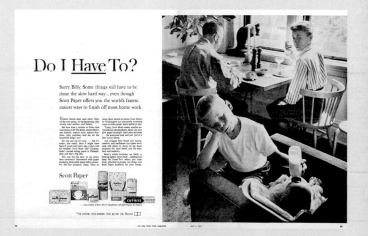

This Scott Paper advertisement, which featured Bubley's photograph of Sally
Forbes' family at breakfast, won an Art Directors Club award in 1960. The copy,
"Do I <u>Have</u> To?" refers to young Philip Forbes's impatience at feeding a bottle
to his infant sister Melanie. The eye-catching photograph is only tenuously linked
to Scott Paper products.

LAGO REFINERY, ARUBA, 1957
Pepsi-Cola International

Bubley's photographs of the Esso refinery in Aruba are
among her finest industrial compositions. In January
1958, *Panorama* published an eight-page photo-essay,
"Aruba, Pipeline of the World."

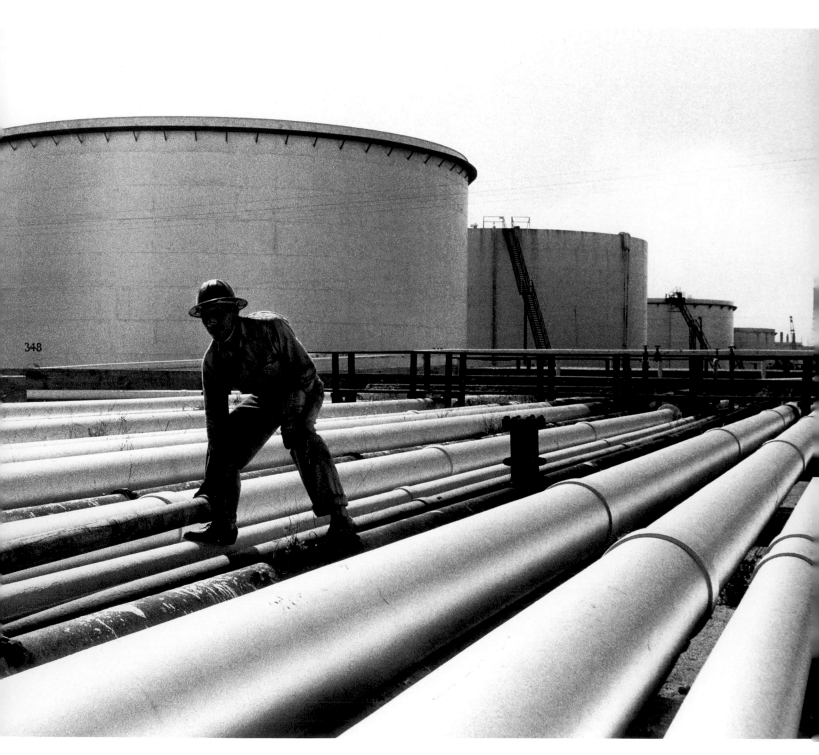

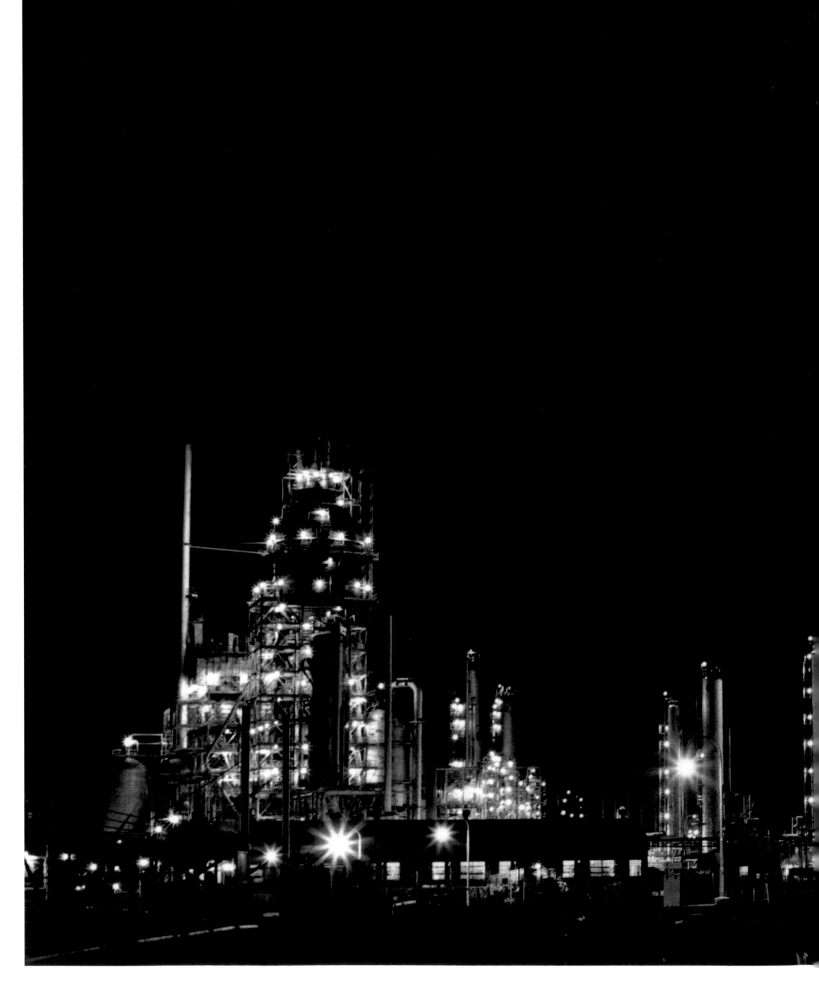

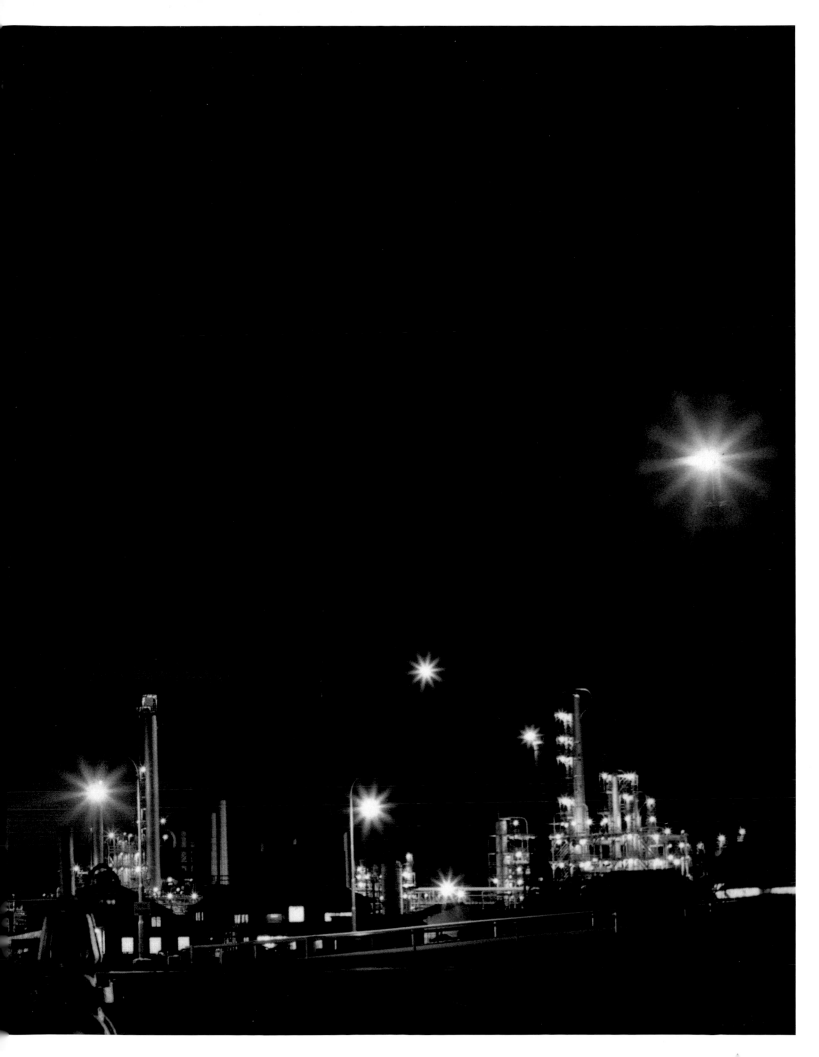

BRAZIL, 1956
Pepsi-Cola International

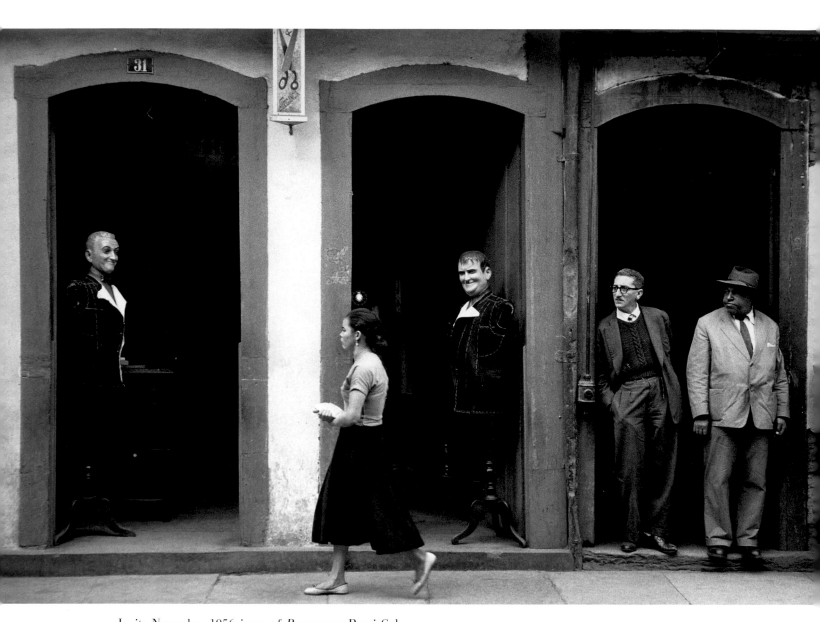

In its November 1956 issue of *Panorama*, Pepsi-Cola featured Bubley's Brazilian photographs of Porto Alegre's new airport but did not publish this witty street scene taken in Ouro Preto. Bubley submitted the photograph to *Photography Annual*, where it appeared as the lead image in "The Playful Camera" (1958) and earned her an Art Directors Club award.

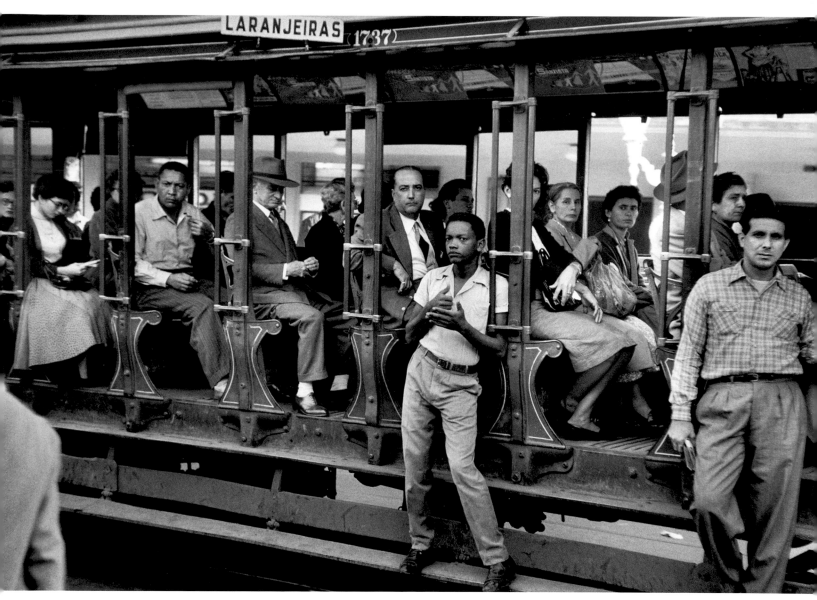

Trolley in Rio De Janeiro

ISTANBUL, 1965
Pan-American World Airways

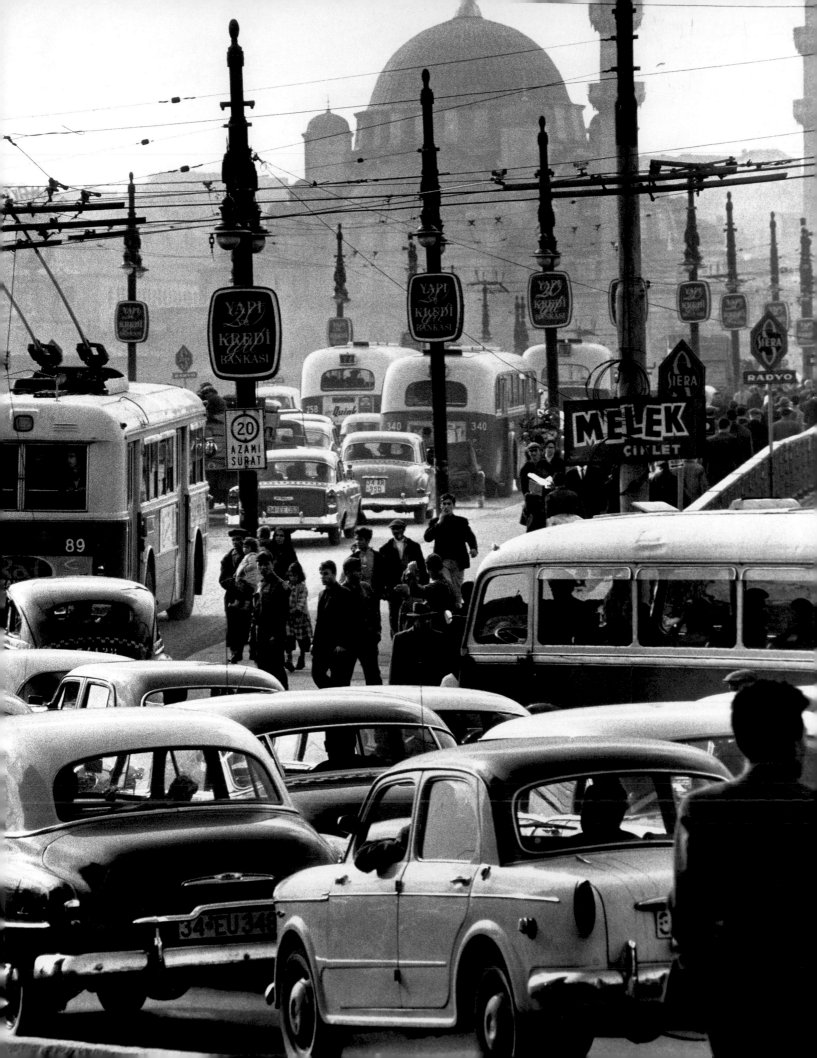

In 1954, Bubley turned over the lease of her West 47th Street apartment to Edward Steichen, who needed a New York *pied-a-terre*, and moved to a third-floor walk-up at Broadway and West 56th Street. She loved the new, larger apartment with its twenty-six-foot expanse of windows and its second bedroom and bathroom, which became an office and darkroom.

In 1958, she adopted a six-month-old Dalmatian named Sheba, and from five to eight o'clock every morning, Bubley walked Sheba in Central Park, before heading to Carlos' studio, a fashionable gym near Carnegie Hall. Bubley transformed her daily experiences into magazine stories: in July 1960, *Pageant* published, "Stay 'Fiddle-Fit,'" about Carlos; in November 1960, *Look* published, "A Birthday Party for Van," about Sheba and a Great Dane named Van; and in March 1963, *U.S. Camera* published, "Portrait of a Place," Bubley's photographs of Central Park. Bubley also worked on proposals for books about Sheba and Central Park, but the era of well-illustrated coffee table books had not yet arrived, and the books were never published.

In the 1970s, Bubley published three books, each using photography as an educational tool. *How Puppies Grow* (1972) and *How Kittens Grow* (1975) were award-winning children's books which were translated into Spanish and Dutch. The third book, *A Mysterious Presence* (1979), used macro-photography to detail the growth of the plants that Bubley grew in her apartment. In the 1980s and 1990s, as new audiences discovered her work, her health began to fail, and in 1998, she died of cancer.

Bubley's career illustrates the best of American photojournalism. For twenty-five years, she completed an unbroken chain of first-rate industrial, magazine, and advertising assignments, flourishing under the demands and deadlines of editors, writers, and art directors. She did not dwell on the politics of her employers or her lack of control over final products but remained determined to do her job well.

Bubley was more than a consummate professional. She had a gift for capturing surprisingly intimate behavior. She often said that people became "bored" with her and forgot that she was there, but what was far more important was Bubley's candor with her subjects. Although she chose a small camera that other photographers used surreptitiously, Bubley always explained who she was and for whom she was working. And despite the inherently invasive character of her work, especially on assignment for national magazines, she approached each situation with genuine interest and curiosity. Sensing this, her subjects trusted her and revealed themselves. Because of her honesty and resolve, Bubley was able to create an unusually rich documentation of mid-twentieth century American life — one that, to use her words again, is "educational, instructive, and provides aesthetic pleasure."

— Bonnie Yochelson

OPPOSITE PAGE: Working with her friend, Ed Sammis, editor of Standard Oil's journal, the *Lamp*, Bubley planned a book about her Dalmatian Sheba. An excerpt from Sammis' proposal captures the spirit of the project:
Our star, the dog Sheba, a Dalmatian, is a special kind of dog — a personality pup, off-beat, a shameless ham with a genius for mugging, living under special circumstances which allow her to enjoy life and to have a particularly good time. She is not typical of a city dog, not typical of anything; she's just herself. Therefore we feel that she should not be forced into a mold nor have any documentary weight put on her.... this, in turn, dictates a loose, episodic treatment. The book would take the shape of a kind of dog "Eloise" or "Fernandel." This treatment would give the charm of the pictures their best chance to come through.

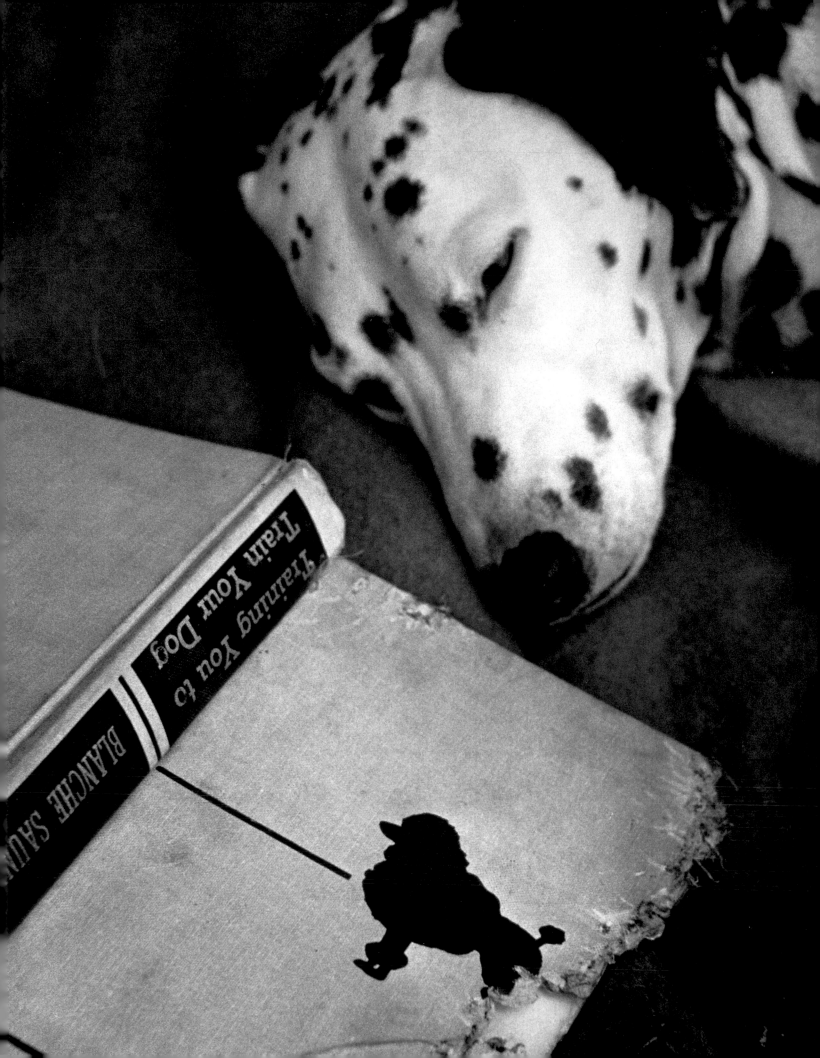

SHEBA & CENTRAL PARK

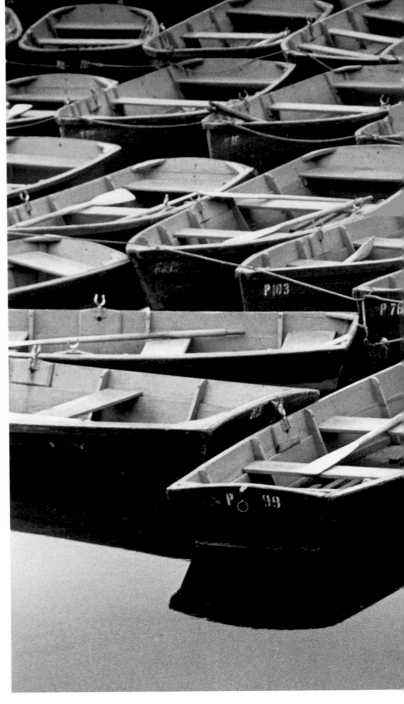

Early-morning dog walking in Central Park became the anchor of Bubley's life, when in 1958 she adopted Sheba, her first of three Dalmatians. Bubley envisioned a picture book about the park in the early morning hours, when dog walkers, birdwatchers, lovers, and homeless people inhabited it, which unfortunately was never published.

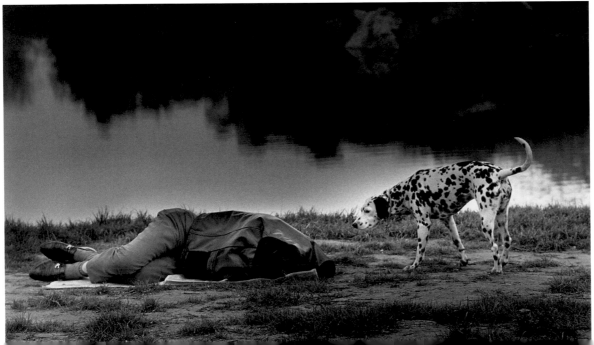

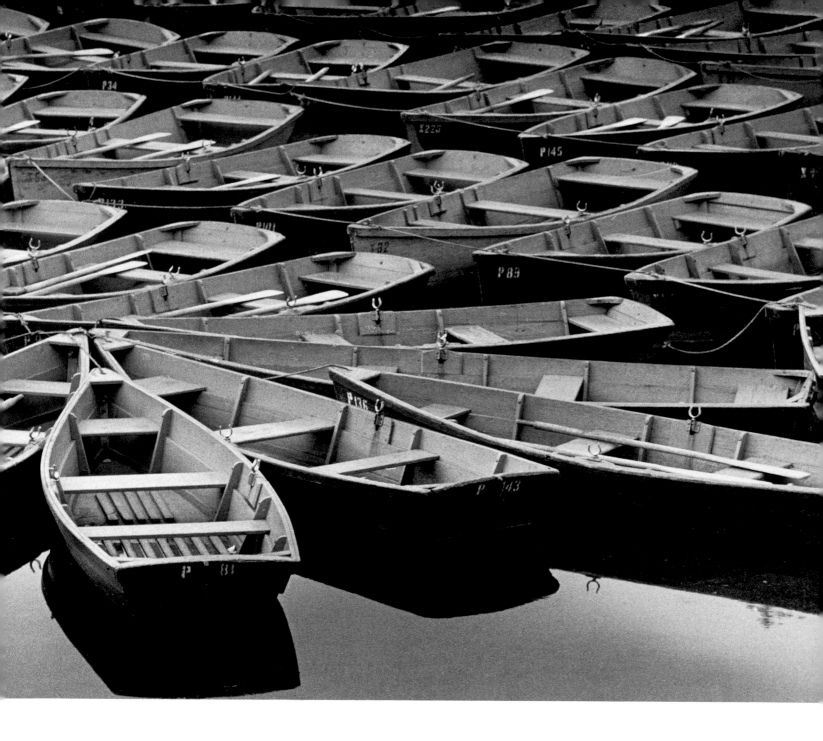

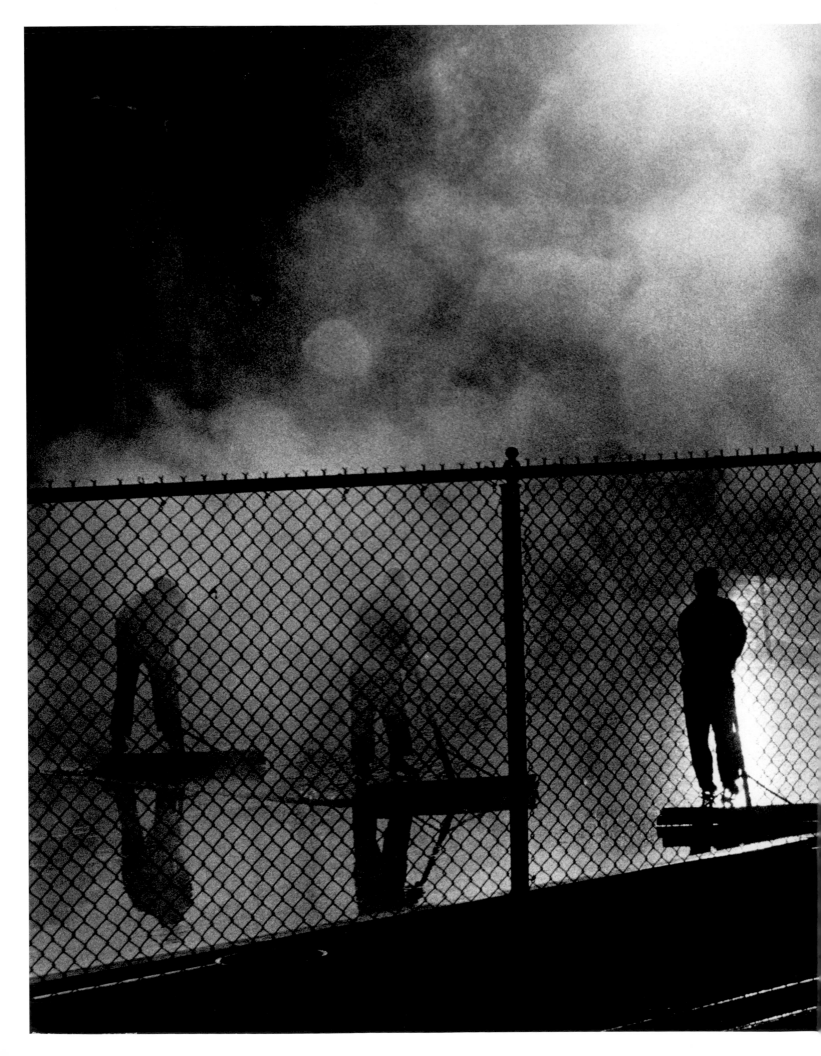

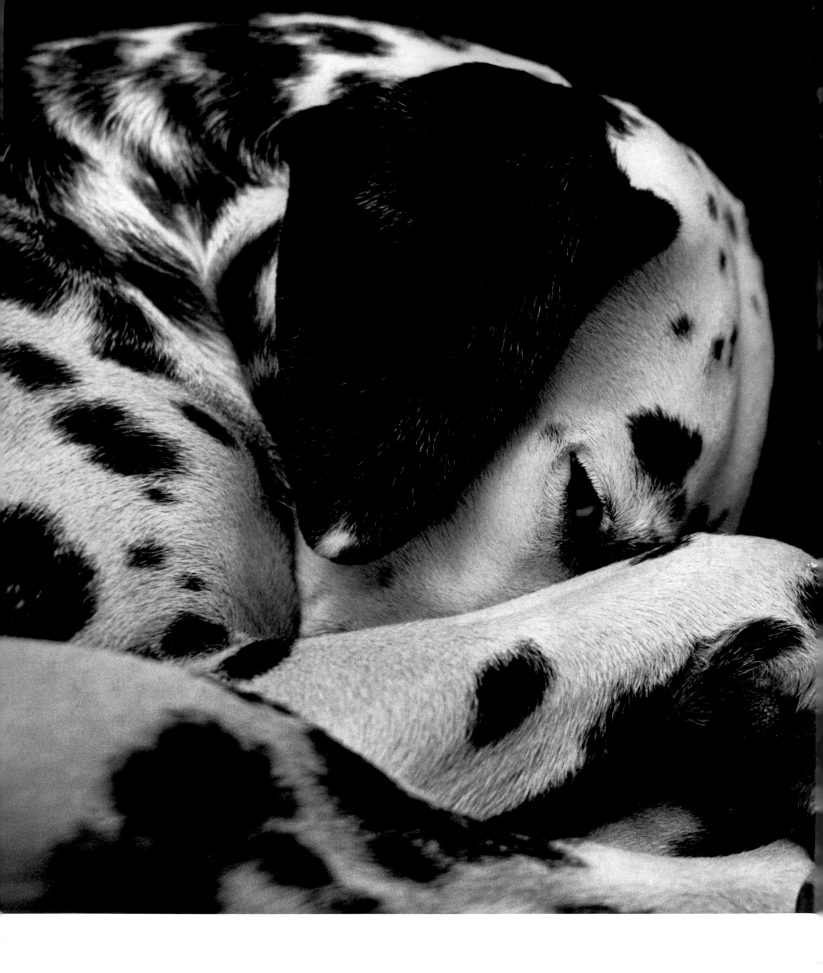

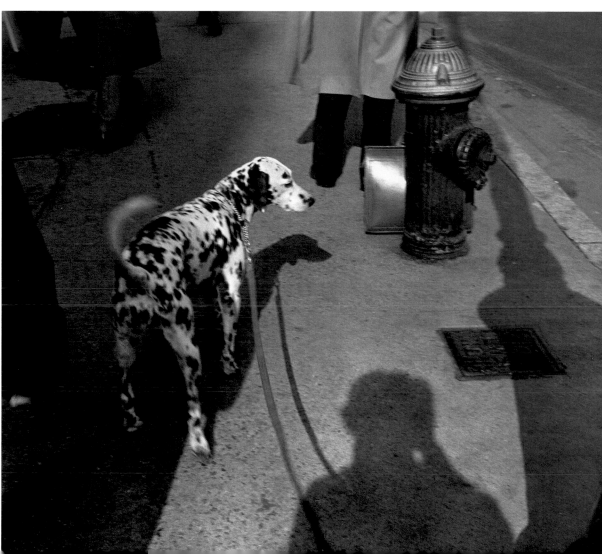

ENDNOTES

1. Untitled typescript, Esther Bubley Archive
2. Untitled typescript, Esther Bubley Archive
3. John Durniak, "Focus on Stryker," *Popular Photography*, September 1962, p. 111
4. "Life in a Boardinghouse in Washington, D.C., Photographs by Esther F. Bubley," Esther Bubley Archive
5. "Bus Drivers," p. 3, Esther Bubley Archive
6. "Louisville to Nashville," p. 15, Esther Bubley Archive
7. Standard Oil Photographic Library guest books, Roy Stryker Papers, Special Collections, University of Louisville
8. Bubley's statement on Stryker submitted to John Durniak, executive editor of *Popular Photography*, May 1962, Esther Bubley Archive
9. "The Children of Esso," by John Vachon, Esther Bubley Archive
10. "Focus on Stryker," p. 111
11. "Town Portrait," *Minicam*, December 1945, p. 21
12. Roy Stryker to Richard Doud, October 17, 1963, Smithsonian Archives of American Art
13. " Russell Lee on the Standard Oil Company (N.J.) Photographic Project," interview by Steve W. Plattner, April 11, 1979, p. Special Collections, University of Louisville
14. Pocket journal, Esther Bubley Archive
15. Jack Solomon to Bonnie Yochelson and Tracy Schmid, May 7, 2004
16. Mary Taylor, Director, Division of Reports, Children's Bureau to Bubley, October 27, 1952, Esther Bubley Archive
17. John G. Morris, *Get the Picture, A Personal History of Photojournalism* (University of Chicago Press, 2002), p. 108.
18. *Ibid*
19. Interview of Esther Bubley by Tony Van Witsen, November 4, 1984, International Center of Photography Library
20. "The People Who Go To Hospitals," *Life*, November 28, 1951, p. 48
21. "Story: Children's Hospital – Pittsburg, Breakdown of Material in File," Esther Bubley Archive
22. Edwin Locke to Esther Bubley, n.d., Esther Bubley Archive
23. Morton Reif, "Esther Bubley: Realism," *Photo Arts*, May 1951, p. 27
24. John R. Whiting, *Modern Photography*, December 1951, p. 120
25. Pocket journal, Esther Bubley Archive
26. Esther Bubley to Roy Stryker, April 5, 1954, Roy Stryker Papers, Special Collections, University of Louisville
27. Sidney M. Maran to Ed Hannigan, Editor, *U.S. Camera*, September 17, 1956, Esther Bubley Archive
28. "Esther Bubley," typescript with "Panorama" written in Bubley's hand across the top margin, p. 4, Esther Bubley Archive
29. "Proposal," Lind Brothers, p. 1, Esther Bubley Archive

BOOKS AND ARTICLES BY ESTHER BUBLEY

Charlie Parker. Paris, France: Filipacchi, 1995. With Hank O'Neal.

Esther Bubley's World of Children in Photographs. New York: Dover Publications, 1981.

How Kittens Grow. New York: Four Winds Press, 1973. With Millicent E. Selsam.

How Puppies Grow. New York: Four Winds Press, 1971. With Millicent E. Selsam.

"Industrial." Published in *35-mm Photography Workshop Annual*, 1959.

A Mysterious Presence: Macrophotography of Plants. New York: Workman Publishing, 1979. With Percy Knauth.

Rockefeller New York: A Tour by Henry Hope Reed. New York: Greensward Foundation, Inc., 1988.

Zoo Pals. New York: The Ridge Press, 1960. With Ann McGovern.

BOOKS AND ARTICLES ABOUT ESTHER BUBLEY

Anderson, James C., ed. *Roy Stryker, The Humane Propagandist*. Louisville, Kentucky: J.B. Speed Art Museum, 1977.

Davol, Leslie T. "Shifting Mores: Esther Bubley's World War II Boarding House Photographs." *Washington History*, Fall/Winter 1998–99.

Dieckmann, Katherine. "A Nation of Zombies." *Art in America*, November 1989.

Durniak, John. "Focus on Stryker." *Popular Photography*, September 1962.

Ellis, Jacqueline. *Silent Witnesses: Representations of Working-Class Women in the United States*. Bowling Green, Ohio: Bowling Green State University Press, 1998.

Fisher, Andrea. *Let Us Now Praise Famous Women: Women Photographers for the U.S. Government, 1935 to 1944*. New York: Pandora Press, 1987.

Fleischauer, Carl and Beverly W. Brannan, eds. *Documenting America, 1935–1945*. Berkeley: University of California Press and Library of Congress, 1988.

Gee, Helen. *Limelight: A Greenwich Village Photography Gallery and Coffeehouse in the Fifties: A Memoir*. Albuquerque: University of New Mexico Press, 1997.

Keller, Ulrich. *The Highway as Habitat. A Roy Stryker Documentation, 1943–1955*. Seattle: University of Washington Press, 1986.

Lemann, Nicholas. "Esther Bubley's America." *American Heritage*, May 2001.

Lemann, Nicholas. *Out of the Forties*. Austin: Texas Monthly Press, 1983; reprint Smithsonian Institution Press, 1998.

Lukitsh, Joanne. *Esther Bubley On Assignment: Photographs Since 1939*. Bethune Gallery, University at Buffalo, State University of New York, 1990.

Maloney, Tom. "Standard Oil's Great Photo Experiment." *U.S. Camera*, December 1948.

Morris, John G. *Get the Picture: A Personal History of Photojournalism*. Chicago: University of Chicago Press, 2002.

Plattner, Steven W. *Roy Stryker: U.S.A., 1943–1950*. Austin: University of Texas Press, 1983.

Rabinowitz, Paula. *Black & White & Noir*. New York: Columbia University Press, 2002.

Reif, Morton. "Esther Bubley: Realism." *Photo Arts*, May 1951.

Rosenblum, Naomi. *A History of Women Photographers*. New York: Abbeville Press, 1994.

Ruisinger, Tina and Ted Croner. *The Faces of Photography: Encounters With 50 Master Photographers of the 20th Century*. Zurich: Edition Stemmle, 2002.

Schulz, Constance B. and Steven W. Plattner, eds. *Witness to the Fifties: The Pittsburgh Photographic Library, 1950–1953*. Pittsburgh: The University of Pittsburgh Press, 1999.

Stryker, Roy E. "Documentary Photography in Industry." *U.S. Camera Annual*, 1947.

Stryker, Roy E. and Nancy Wood. *In This Proud Land: America 1935-1943 As Seen in the FSA Photographs*. Greenwich, Connecticut: New York Graphic Society Ltd., 1973.

Whiting, John R. "Esther Bubley." *Modern Photography*, December 1951.

UNPUBLISHED MANUSCRIPTS

Esther Bubley interview by Tony Van Witsen. International Center of Photography library.

Roy Stryker interview by Richard Doud, 1963-65. Archives of American Art, Smithsonian Institution.

Harold Corsini, Russell Lee, Sol Libsohn, Gordon Parks, and Edwin and Louise Rosskam interviews by Steven W. Plattner, 1979-80. Roy E. Stryker Papers, Special Collections, University of Louisville.

For more information about Esther Bubley, please visit www.estherbubley.com

SOLO EXHIBITIONS

1952. *Photographs by Esther Bubley*. Children's Bureau, Social Security Administation, Washington, D.C.

1952. *Esther Bubley: "Realism" in Photography*. Village Camera Club, New York.

1956. *Esther Bubley*. Limelight Gallery, New York.

1960. *These Are Our Children*. President's National Committee for the White House Conference on Children and Youth, Children's Bureau, Washington, D.C.

1960. *Photographs by Esther Bubley*. The Douglas County Historical Museum, Superior, Wisconsin.

1960. *Photographs by Esther Bubley*. Berkshire Playhouse, Stockbridge, Massachusetts.

1960. *The Photography of Esther Bubley*. New York Public Library, Hudson Park Branch, New York.

1961. *Esther Bubley*. Duluth Public Library, Duluth, Minnesota.

1966. *Esther Bubley: The Selective Traveler*. Eastman Kodak Gallery, Grand Central Terminal, New York.

1966. *The Photography of Esther Bubley*. Morristown Unitarian Fellowship, Morristown, New Jersey.

1974. *Central Park*. Federal Hall, New York.

1983. *Esther Bubley*. Ledel Gallery, New York.

1988. *The Rockefellers' New York*. New York School of Interior Design, New York.

1989. *Esther Bubley*. Ledel Gallery, New York.

1989. *Esther Bubley: Photographs from the 1940s & 1950s*. Kathleen Ewing Gallery, Washington, D.C.

1990. *Esther Bubley on Assignment: Photographs Since 1939*. University at Buffalo, State University of New York, Bethune Gallery, Buffalo, New York. Traveled to Minneapolis College of Art and Design, Minneapolis, Minnesota.

1995. *Photographs by Esther Bubley*. Phillips Collection, Washington, D.C.

2001. *Esther Bubley: American Photo-journalist*. UBS/PaineWebber Art Gallery, New York. Traveled to Boston University Art Gallery and Silver Eye Center for Photography, Pittsburgh, Pennsylvania.

2003. *America As It Was: The Photojournalism of Esther Bubley*. Akron Art Museum, Akron, Ohio.

2003. *Esther Bubley … "and leave the driving to us."* Gallery 292, New York.

GROUP EXHIBITIONS

1947. *First Women's Invitation Exhibition*. The Camera Club, New York.

1948. *In and Out of Focus*. Museum of Modern Art, New York.

1949. *Polio Posters*. National Foundation for Infantile Paralysis, Museum of Modern Art, New York.

1950. *Pictures of People*. Pittsburgh Photographic Library, Carnegie Museum of Art, Pittsburgh, Pennsylvania.

1950. *Exhibition Fifty*. The Camera Club, New York.

1950. *Six Women Photographers*. Museum of Modern Art, New York.

1952. *New England, A Photographic Interpretation*. De Cordova & Dana Museum, Lincoln, Massachusetts.

1952. *Diogenes with a Camera*. Museum of Modern Art, New York.

1955. *Family of Man*. Museum of Modern Art, New York.

1957. *Photographs by Esther Bubley, John Collier, Gordon Parks, John Vachon and Todd Webb*. Village Camera Club, New York.

1957. *Children of the World*. Pepsi-Cola International, Abraham & Straus, New York.

1958. *Around the World*. Pepsi-Cola International, Kodak Exhibition Center, Grand Central Terminal, New York.

1960. *Photography in the Fine Arts II*. Metropolitan Museum of Art, New York.

1961. *Esther Bubley and John Vachon*. Gallery 100, Princeton, New Jersey.

1962. *Invitation Exhibition of Photography*, The Print Club, Philadelphia, Pennsylvania.

1964. *Photography Show*. Westchester Art Society, White Plains, New York.

1965. *Profile of Poverty*, The Smithsonian Institution, Washington, D.C.

1965. *Photography in the Fine Arts*. Kodak Pavilion, New York World's Fair, Queens, New York.

1981. *American Children*. Museum of Modern Art, New York.

1983. *Out of the Forties*. Amon Carter Museum, Fort Worth, Texas.

1983. *The Great East River Bridge 1883–1983*. Brooklyn Museum of Art, Brooklyn, New York.

1983. *Roy Stryker: U.S.A., 1943–1950.* International Center of Photography, New York.

1988. *Master Photographs from "Photography in the Fine Arts" Exhibition, 1959–1967.* International Center of Photography, New York.

1988. *Women Photographers of the Farm Security Administration (1935–1943).* Kathleen Ewing Gallery, Washington, D.C.

1988. *Documenting America, 1935–1943.* Library of Congress, Washington, D.C.

1989. *On Assignment: Documentary Photographs from the 1930's and 1940's by Marion Post Wolcott and Esther Bubley.* Art Institute of Chicago, Chicago, Illinois.

1994. *The Reckless Moment.* Art Institute of Chicago, Chicago, Illinois.

1995. *Women Come to the Front: Journalists, Photographers and Broadcasters During World War II.* Library of Congress, Washington, D.C.

1996. *Legacy of Light.* Cleveland Museum of Art, Cleveland, Ohio.

1996. *A History of Women Photographers.* New York Public Library, New York.

1997. *Beaux Arts New York.* PaineWebber Art Gallery, New York.

1997. *Defining Eye: Women Photographers of the Twentieth Century.* Saint Louis Art Museum, St. Louis, Missouri.

1997. *Pittsburgh Revealed: Photographs Since 1850.* Carnegie Museum of Art, Pittsburgh, Pennsylvania.

1998. *Eight Million Stories· Twentieth-Century New York Life in Prints and Photographs from the New York Public Library.* New York Public Library, New York.

1999. *The American Century: Art & Culture 1900–1950.* Whitney Museum of American Art, New York.

1999. *Propaganda & Dreams, Photographing the 1930s in the USSR and the US.* Corcoran Gallery of Art, Washington, D.C.

2000. *Sitting Pretty: Photographs from the Marianne Moore Collection.* Rosenbach Museum & Library, Philadelphia, Pennsylvania.

2002. *Women of Our Time: Photographs from the National Portrait Gallery.* Smithsonian National Portrait Gallery, Washington, D.C.

2003. *Celebrating Central Park, 1853–2003.* Hirschl & Adler Galleries, New York.

This book is the culmination of an effort begun in 1998, when Esther Bubley passed away and her niece Jean Bubley was named executor of the estate. Although Jean initially knew little about photography, she was committed to preserving and promoting her aunt's life work. As a computer software consultant, Jean's first step was to set up a website (www.estherbubley.com), which has attracted a diverse audience, from high-school students writing research papers to subjects Bubley photographed more than forty years ago. For advice on collection care and access, Jean found Janet Murray, an experienced freelance archivist, who in turn trained Tracy Schmid. Tracy has created a model archive, establishing a database and rehousing 50,000 vintage prints, contact sheets, negatives, color slides, and documents. Jean devoted funds from the Estate of Esther Bubley towards this project, and two generous grants from The Judith Rothschild Foundation have helped further work on the collection. A third grant from The Judith Rothschild Foundation helped support the publication of this book.

One of the most important contributors to Jean's efforts has been Sally Forbes, Esther's close friend, who worked for ten years as Esther's business representative. Sally and I organized the retrospective exhibition, *Esther Bubley: American Photo-Journalist*, which took place at the UBS Art Gallery in the summer of 2001 and was sponsored by The Beaux Arts Alliance, of which Sally is Executive Director. A reduced version of the UBS exhibition traveled to the Boston University Art Gallery and the Silver Eye Center for Photography in Pittsburgh; in 2003, the Akron Art Museum mounted a Bubley exhibition, and the Howard Greenberg Gallery showed a selection of her prints. It was the interest generated by these exhibitions that inspired Ellen Harris, Executive Director of the Aperture Foundation, to conceive this monograph.

Research for the exhibitions and the book has been a team effort. Jean, Tracy, and I interviewed several of Esther's friends and colleagues: Sally Forbes; photographers Sol Libsohn and Gordon Parks; picture editors John G. Morris and Tina Fredericks; and Esther's close friends Dodi Schultz and David Farquharson. Others contributed recollections as well: Helen Gee, Clyde Hare, Dr. Madeline Naegle, Priscilla Coit Murphy, Grace Rothstein, Jack Solomon, and Sam Vaughan. Tony van Witsen, Tina Ruisinger, and Tyrone Georgiou supplied transcripts and notes from their interviews with Esther Bubley.

Professor Georgiou of the University at Buffalo, who organized a Bubley exhibition in 1990, was kind enough to permit us to reuse his title, "Esther Bubley: On Assignment."

Many of Jean Bubley's family offered invaluable memories and research support: Frances Bubley, Jean's mother and Esther's sister-in-law; Esther's sister Anita Greenspan and her husband Harry Greenspan; Esther's sister Claire Tepper and her son Donald Tepper; Jerry Raines, Esther's nephew; Ruth Ellin, Jean's aunt and a high school friend of the Bubley sisters; Ruth's daughters Phyllis Ellin and Laura Handlin; and Jean's cousin Sonia Kovitz. Jean's cousin Johanna Kovitz, who transcribed eight interviews, deserves special mention.

Library research centered on the Farm Security Administration/Office of War Information Collection at the Library of Congress; the Standard Oil Company (New Jersey) Photographic Library at the University of Louisville, Kentucky; and the Pittsburgh Photographic Library at the Carnegie Library of Pittsburgh and the Carnegie Museum.

We are deeply grateful to all who generously helped make possible the Bubley exhibitions and this book. In addition to those already mentioned, we offer special thanks to: Colin Thompson, UBS Art Gallery; David Garrard Lowe, The Beaux Arts Alliance; Linda Florio and Daniel Schnur, who designed the UBS exhibition; Gus Kayafas, Palm Press, Inc.; Barbara Tannenbaum, Akron Art Museum; Howard Greenberg and Karen Marks, Howard Greenberg Gallery; John Stomberg, Stacey McCarroll, and Chris Newth, Boston University Art Gallery; Linda Benedict-Jones, Kaoru Tohara, Sylvia Fein-Ehler, and Amanda Bloomfield, Silver Eye Center for Photography; Beverly Brannan, Library of Congress; Gilbert Pietrzak, Carnegie Library of Pittsburgh; Monica Tamka, Pittsburgh Carnegie Museum; Delinda Buie, James Anderson, Carrie Daniels, and Susan Knoer, University of Louisville; Deborah Bell, Deborah Bell Gallery; and Kathleen Ewing, Kathleen Ewing Gallery; Eric Rachlis and Kristeen Ballard, Getty Images US, Inc.

Many others deserve thanks for further research assistance, including Bradley Androski in Superior, Wisconsin; Pat Bailey of Pepsico; Sue Borello, University of Pittsburgh Press; Grayson Dantzic; Kathy Doak of *Life*; Liz Dodds, George Eastman House; Deirdre Donohue, International Center of Photography; Al Francekevich; Johanna Fiore; Gary Green and Sal Amdursky, Kalamazoo Public Library; James Herschorn; Sid Kaplan; Dr. Robert Lombardo; Theodora Meronek, Superior, Wisconsin Public Library; Kathy Peterson, THE-BEE, Phillips, Wisconsin; Claire and Steven W. Plattner; Amy Rule, Center for Creative Photography; Anne Segan; Andrew Siler; and Dawn Stanford, IBM Archive.

Jean would like to acknowledge the unflagging support of Jim Siler, her business partner, and Margaret Lichtenberg, her closest friend. I am grateful to my husband Paul Shechtman for his unerring editorial hand.

At Aperture, we have been fortunate to work under the steady guidance of editor Lesley Martin and to collaborate again with designer Linda Florio, who has brilliantly captured the spirit of mid-century picture magazines in the design of this book.

— BONNIE YOCHELSON

THIS PROJECT RECEIVED GENEROUS SUPPORT FROM THE JUDITH ROTHSCHILD FOUNDATION.

FRONT COVER: Originally published as part of 'Life Tours the Children's TV Shows," *Life*, December 24, 1951. On the television program *Grand Chance Roundup*, nine-year-old Paul Oudinot held aloft his brother and sister to compete for the chance to work on the Steel Pier in Atlantic City.

BACK COVER: Contact sheets from the same shoot.

EDITOR: Lesley A. Martin
DESIGNER: Linda Florio
PRODUCTION: Bryonie Wise

THE STAFF FOR THIS BOOK AT APERTURE FOUNDATION INCLUDES:
Ellen S. Harris, *Executive Director*; Michael Culoso, *Director of Finance and Administration*; Lesley A. Martin, *Executive Editor, Books*; Nancy Grubb, *Executive Managing Editor, Books*; Lisa A. Farmer, *Production Director*; Andrea Smith, *Director of Publicity*; Linda Stormes, *Director of Sales & Marketing*; Diana Edkins, *Director of Special Projects*; Bronwyn Law-Viljoen, *Work scholar*

A traveling exhibition of Esther Bubley's work is available through the Aperture Foundation. For more information, please contact Diana Edkins, Director of Special Projects and Exhibitions at (212) 505-5555 or e-mail at dedkins@aperture.org.

aperturefoundation
547 West 27th Street, 4th floor
New York, N.Y. 10001
www.aperture.org

Aperture is a non-profit organization devoted to photography in all its forms.

First edition
Printed and bound in Hong Kong
10 9 8 7 6 5 4 3 2 1

Library of Congress Control Number: 2004098598
ISBN 1-931788-57-X

Esther Bubley by Tina Ruisinger, 1997

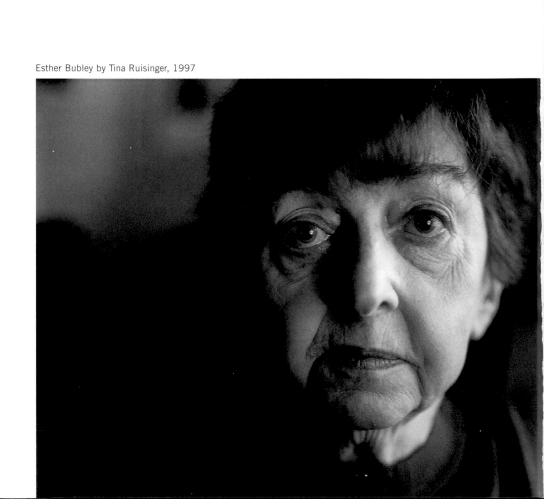